UNDER THE SPELL OF ARABIA

UNDER THE SPELL OF

ARABIA

PHOTOGRAPHS BY MATHIAS OPPERSDORFF

SYRACUSE UNIVERSITY PRESS

First Edition 2001
01 02 03 04 05 06 6 5 4 3 2 1

The paper used in this publication meets the minimum requirements of
American National Standard for Information Sciences—Permanence of
Paper for Printed Library Materials, ANSI Z39.48–1984.∞™

Library of Congress Cataloging-in-Publication Data
Oppersdorff, Mathias T., 1935–
Under the spell of Arabia / photographs by Mathias Oppersdorff.—1st ed.
p. cm.
ISBN 0-8156-0700-8 (alk. paper)
1. Arab countries—Pictorial works. 2. Oppersdorff, Mathias T., 1935—Journeys—Arab
countries. I. Title.
DS36.65.O67 2001
909'.0974927—dc21 00-049265

Printed by Meridian Printing, East Greenwich, Rhode Island

Manufactured in the United States of America

This book is dedicated to two men,
Lieutenant-General Sir John Glubb
and 'Abd-al-Rahman 'Azzam—
one a soldier and the other a statesman—
both of whom guided me toward Arabia.

I ride on: through the morning, through noonday, into the afternoon of another day. Sand dunes and heat. Dunes behind dunes, and no end. Or is this perhaps the end—the end of all my roads, of all my seeking and finding? Of my coming to the people among whom I would never again be a stranger . . . ?

Muhammad Asad

Mathias Oppersdorff's work includes *People of the Road: The Irish Travellers*, published by Syracuse University Press, and *Adirondack Faces*, published by Syracuse University Press and the Adirondack Museum. He has worked for eighteen years as a travel photographer for *Gourmet* magazine.

UNDER THE SPELL OF

Arabia

All men dream: but not equally. Those who dream by night in the dusty recesses of their minds wake in the day to find that it was vanity: but the dreamers of the day are dangerous men, for they may act their dream with open eyes, to make it possible.

Lawrence of Arabia

I dreamed of Arabia and wanted to inhale it by the lungful, to travel freely among bedouin tribes, to feel the bustle of the crowded bazaars, and to once again hear the call to prayer.

So what was my attraction to the desert? I had experienced a taste of it in 1961 when I drove my 2cv Citroën from Paris to Ceylon by way of Syria, Jordan, and Iraq. I was under the spell of Arabia. I wanted to see more and photograph what I could.

I was aware of some of the early photographers whose aim was to define the Arab Lands, both as romantic fiction and as reality. As early as the middle of the last century, Francis Frith (1822–1898) and Félix Bonfils (1831–1885) ventured well beyond where any photographers had gone. The romance of antiquity held a certain fascination for writers and artists of nineteenth-century Europe, and both of these early photographers produced pictures to satisfy a demand for scenes of the exotic.

Unlike these early photographers whose work depicted architecture and landscape, I was not interested in showing what Arabia looked like per se. I wanted to do something interpretive and let my Arabian experience develop a life of its own. When one goes into the desert, one must be open to new possibilities, be ready to accept the unknown. Having no deadlines and no one to please but myself, I was ready to trust my own vision.

Arabia would be tough going: Islamic culture does not encourage photography, travel for the most part was forbidden, and I didn't speak Arabic. But everything that happens, Islam teaches, is *maktub*, or "written," and in spite of the many obstacles, I felt that it was my destiny to go to Arabia and fulfill my dream. In some ways I felt like a Victorian gentleman traveler, and I was definitely an idealist. That was in the early seventies, a long time ago in terms of the vast social changes that have occurred in the region. The shift from traditional Islamic culture to the underpinning of western technology was hap-

pening at a rapid pace. Arabia was changing, I was young, a romantic at heart—and we met in the past. Now as I go through my old negatives, struggling with Parkinson's, I think of my Arabian days.

Dreams always have their beginnings. My dream of going to Arabia began to unfold at the Plaza Hotel in New York City. I was honored to have known 'Abd-al-Rahman 'Azzam, known as Azzam Pasha, who lived at the hotel and was involved in United Nations activities. An Arab statesman, Azzam came from a distinguished Egyptian family that originated in Arabia centuries ago. Founder and first secretary general of the Arab League (1945–52), he was acquainted with all the major figures in the Muslim world, including Kemal Atatürk and Reza Shah of Iran. A soldier, journalist, writer, diplomat, and cabinet minister, he was described by many writers as one of the greatest statesmen of contemporary Islam. Azzam's book, *The Eternal Message of Muhammad,* a masterwork and a source of inspiration for me, taught me much about the beauty and wisdom of Islam.

I owe my first venture into the desert to Azzam's son-in-law, Prince Muhammad ibn Faisal, the grandson of Ibn Saud, the founder of Saudi Arabia. Faisal provided me with everything: a Toyota Land Cruiser; a four-wheel drive truck; drivers; a guide; and a cook, whose name was Ibrahim. During my twelve weeks in Saudi Arabia, I made two long trips: one south through the mountains of Asir, almost to the border of the Yemen; another north through the Hejaz, where I saw the Turkish railway that Lawrence blew up in 1916 and 1917. The railway was still as he left it: twisted tracks and overturned locomotives. From this area, we made one short trip east through Central Arabia to the Persian Gulf.

My guides did not know what to think of me at first—a tall, blond *nasrany* (from Nasarine, meaning

Christian) from a foreign land. They had been instructed to show me the country so I could get my pictures, but photography meant nothing to them. Their lack of understanding led to some frustrating situations. Once, after driving in the desert for some hours, we came upon a small oasis, a ring of palm trees surrounding a pool of water. In the middle of the pool stood a beautiful white horse. What a picture! I was not allowed to take it. My guides did not feel like stopping.

On another day when we were having lunch, a man carrying a rifle came into our camp. Being interested in weapons, I asked if I could see the rifle, a Lee Enfield .303. As I aimed it, simply to appreciate its balance, everybody insisted that I shoot. They wanted to see what I could do. I selected a white stone about the size of a teacup on the hillside about a hundred yards away and blasted it to smithereens. My guides were so delighted that from then on I could do no wrong. When the chief guide reported back to Prince Muhammad, he summed up the trip in one sentence: "The foreigner can shoot—he is a warrior!" I finally had their respect.

Throughout the kingdom, we often traveled with a few sheep. They were kept in the truck while traveling and let out to forage during our lunch breaks. Every now and then, Ibrahim, the cook, would slaughter one, and we would feast on mutton for the next few days. Often bedouin would chance by our camp and eat with us. No one is refused hospitality. It is the custom to share food with passing strangers.

Between desert trips, I passed my time in Jidda, the gateway to Mecca. "Jidda" means "grandmother," and the city is believed to be the burial place of Eve, the mother of us all. Here I had time to walk the back streets and the waterfront, and I would see people struggling with the hardships of

life. This was the poor Arabia, the "other Arabia" not known to the West, where the difficulties of the human condition were made more bearable by strong faith.

Islam has the shortest of all creeds: *La illaha illallah wa Muhammad rasul Allah:* "There is no God but God, and Muhammad is the apostle of God." In Arabic, this creed has a musical ring to it. The words are so simple that anyone can learn them, and yet the words are so profound that lifetimes are spent studying this creed. Islam gives the Arabs a sense of solidarity and courage in battle. To die in the service of Allah means immediate entrance into Paradise.

The pilgrimage to Mecca, known as the Hajj, is a religious obligation that every orthodox Muslim must perform, if possible, once in a lifetime. It is toward Mecca and specifically toward the sanctuary of the Kaaba—a symbol of God's Oneness—that the entire Islamic world turns to pray five times each day. The Prophet Muhammad did not claim to be the founder of a new religion. Islam, the self-surrender to God, has been man's natural yearning since the beginning of time. The Prophets—Abraham, Moses, and Christ—taught this union with the One God, and Muhammad, the Koran teaches, fulfilled this continuous message.

How different the Hajj has become since the Faithful braved the dangers of long journeys from all corners of the Muslim world. Now hundreds of thousands of pilgrims come by airplane to Jidda and take air-conditioned buses to the Holy City. As the trip has become easier, the spirit of an earlier time can hardly be the same. In *The Road to Mecca* Muhammad Asad, a convert from Judaism who made his pilgrimage to Mecca by camel in 1927, shared his first experience of brotherhood as a Muslim among Muslims:

From all sides you could hear people speaking and murmuring in many tongues. Sometimes a few pilgrims called out in chorus: *"Labbayk, Allahumma, labbayk!"* "For Thee I am ready, O God, for Thee I am ready!" . . . We ride on rushing, flying over the plain, and to me it seems that we are flying with the wind, abandoned to a happiness that knows neither end nor limit . . . and the wind shouts a wild paean of joy into my ears: "Never again, never again, never again will you be a stranger!"

My brethren on the right and my brethren on the left, all of them unknown to me but none a stranger: in the tumultuous joy of our chase, we are one body in pursuit of one goal. Wide is the world before us, and in our hearts glimmers a spark of the flame that burned in the hearts of the Prophet's Companions. (1954, 399)

As a Christian I could not go to Mecca or Medina, but I still wanted to continue my Arabian experience and see what I could. In Jordan I came the closest to finding the old Arabia that I had dreamt of, where the bedouin still cling to their traditional way of living. Their nomadic culture—with its warlike qualities of hardihood and mobility—has always appealed to me.

One day I sipped coffee with the son of Auda, sheikh of the Abu Teyeh clan of the Howeitat tribe. One of the greatest bedouin warriors, Auda was with Lawrence on his surprise attack on Aqaba during the Arab Revolt. According to Lawrence, he was the greatest fighting man in Northern Arabia. Auda's son's peaceful and sedentary life, quite different from that of his father, reflects one way Arabia is changing. In many other ways the people and the land have not changed. Although Arabia's economy is no longer based on breeding camels, a bedouin

may still live in a black tent, known as a *bayt-al-sha'r* (for "house of hair"), but one is apt to see a truck parked outside the tent instead of a camel.

One of my most memorable moments in Jordan was when I rode at dawn on horseback with my bedouin guide into the Nabatean city of Petra. A narrow gorge led directly to the façade of the Treasury. In Petra one could see something of the old that was not changing. Only the scores of tourists that would come down from Amman later in the day would jar the silence.

The Yemen, for me, was the most beautiful country in all of Arabia, with the possible exception of the interior of Oman. It remained hidden in mysterious isolation until long after World War II. The people in the Yemen seemed the happiest and friendliest I met in my Arabian travels.

When I arrived in the Yemen in 1970, vestiges of the revolution set in motion by an army coup and supported by the regime in Egypt were still evident: burned out tanks, pictures of Nasser everywhere, movies about Che Guevara, and talk about aid from Eastern bloc countries. Shops still displayed names such as "Revolution Bakery for Fresh Bread" or "Freedom Store."

I was amazed to see how many people carried automatic rifles. Throughout Arabia guns were still a symbol of manhood and a valuable possession. They were only forbidden in the movie theaters because some well-meaning tribesmen, while watching a western movie, had sprayed the screen with machine gun fire to help the cavalry as it was being pursued by Indians. In airplanes, I became accustomed to seeing men boarding with their guns as well as with their sheep and goats. Some airplanes did not have seats, so we clung to netting fastened along the sides. It disturbed me to see the Sana'a runway

strewn with burned-out plane wrecks. We referred to the local airline as *insha-Allah,* "God Is Willing" Airline.

One group that I photographed in the Yemen was an outcast clan of musicians and street sweepers of Ethiopian origin, known as the *Akhdam*. While photographing them for an article published by the British *Geographical Magazine* (June 1976), I got the news that my mother was dying of cancer, and so I returned home. My travels in the Yemen had come to an end.

Several months later I returned to Arabia and visited Oman, which proved to be also a very colorful and interesting place. In 1972, when I was in Oman, the United States was dealing with the Watergate scandal. Oman was just getting on its feet after the royal coup of 1970. The new ruler, Sultan Quaboos bin Said, was beginning to open the doors to his country and was building schools and clinics.

At that time Oman—and the United Arab Emirates—seemed to me reminiscent of the last outpost of the British *Raj*. The army life I experienced was straight out of a Rudyard Kipling novel, with British officers leading indigenous troops. Some of the older officers with whom I dined had served in Gurkha regiments, the *corps d'élite* of the Indian Army. Now in the long afternoon of their lives, they were in Arabia in charge of turning local Omani tribesmen—turbans and all—into a modern army.

When I first visited the United Arab Emirates, formerly known as the Trucial States, modern buildings were just under construction. I understand that Abu Dhabi is now a city of high-rises and great avenues. There's even a huge sculpture of a bedouin coffee pot that gets lit up at night in one of the traffic circles. A few years before my arrival there was no airport—just a runway. Imagine this scenario: A jet

waits on the tarmac and two figures on horseback gallop up to the airplane from across the desert. One man dismounts, pulls off his Arab robes revealing a well-cut suit, and climbs on board. The other man, a servant, takes the horses back to the stables. Such a scene will never happen again. Now the way of life in the United Arab Emirates is so fast-paced that it is surpassing that of many other countries. When I was at that newly built Abu Dhabi airport, passengers would not even get off the plane until the movie had finished.

In all the time I spent in Arabia—well over a year—the United Arab Emirates was the only place where I took a trip by camel. I was going from one army post to another. Unfortunately, we crossed no deserts; instead we spent the better part of two days walking along the edge of a road with cars whizzing by—complete with passengers staring at me in disbelief. Not the romantic Arabia I had hoped to find.

Traveling in the early 1970s in Arabia was difficult without the support of a powerful person or organization. In Saudi Arabia, I was privileged to have been the guest of Prince Muhammad ibn Faisal. In the Yemen, my friend Michael Sheehan, who ran the Catholic Relief Organization, was my host. In Jordan, Dany Chamoun, the son of a president of Lebanon, introduced me to Arab *sheikh*s. And in Oman and the U.A.E., the army kept me out of harm's way.

Arabia defied and resisted me. Photographing took a great deal of patience and persistence to overcome some inherent problems. Historically, non-Arabs were regarded with suspicion. In my case, since my motives were not always clear to them, both westerners and Arabs were only tolerant of my presence. Consequently failure, rejection, and loneliness became as much a part of my Arabian experience as was my obsession with it.

I would like to think that it was my openness that allowed photography to happen, but in many cases, being the guest of someone the Arabs respected made my photography acceptable. The Arabs, usually more hospitable and open than my fellow Europeans, did not know what to do when I wanted to take pictures. Sometimes permission was granted, sometimes denied. It wasn't always clear what was allowable. Once, for example, I stepped out of a pick-up truck to photograph a man building a boat. When he saw my camera he practically attacked me, but when he realized that my driver came from the household of the local governor, he quickly decided that I should take all the pictures I wanted. Being in harmony with my photographic subjects is normally essential for good pictures. In Arabia, cooperation came with connections. Traveling alone would not have worked, nor would it have been any fun.

Photographing women, as one can imagine, was almost impossible. Some women photojournalists from the West have succeeded in getting pictures of Arab women, but usually a western man cannot—or so I thought. I remember walking down a street in Riyadh and being invited into a house by a woman wearing the veil. She had spotted my camera and wanted me to photograph her young daughters. She asked me to take pictures and to give her the roll of film. The daughters were extremely bashful and giggled constantly, but finally they came out from behind a partition to get their pictures taken. They were dressed in quite daring western clothes.

Another time, in an open-air clinic, I managed to photograph women who were waiting to be seen by a western doctor. Photographing these women would have been impossible in their own surroundings, but the waiting room of the clinic acted as a neutral zone between their culture and mine. Here

they did not see anything wrong with my taking pictures. Sometimes this bridge between two worlds made photography possible, but the rules were tricky. For example, at a village well where brightly clad women would go to draw water, there was a photographer who tried to take pictures and was almost knifed by their menfolk. Because his driver knew that photography was wrong, the men assumed that the photographer also knew. I went later to get pictures at the same well, but I went alone. The women thought that I was not aware of the rules, so they did not stop me.

I have always been fascinated by the paintings of the Orientalists. Who can turn away from the magical opulence of Jean-Léon Gérôme's *The Slave Market* or the technical brilliance of *The Snake Charmer*? The Orientalists emphasized their impression of the exoticism and mystery of the Islamic world. It was this exoticism, this timeless world before westernization, that I came to Arabia to find. I got there much too late to have witnessed the last days of bedouin freedom. I had hoped at least to photograph what was left of the old Arabia—in the towns as well as in the countryside—before it disappeared. The reality

and hardships of traveling in Arabia were not romantic—the heat, the flies, and particularly the frustrations of trying to photograph people who don't want their pictures taken, were only a few of the obstacles. By the early 1970s oil money had already begun to change the face of Arabia. Modern construction was replacing traditional architecture, and the bedouin were being transformed by a technological bureaucracy. A part of me felt robbed for having missed much of the "old Arabia" by such a small margin. I did, however, find a spiritual quality to the desert and a genuine hospitality among its people that I will never forget.

Almost three decades have passed since these pictures were taken. I now understand that my photography is mainly about conveying their quality of human dignity and the harsh realities of life in that magnificent landscape. As an image-maker and realist, I trust my eye has been a sympathetic one. Although I came to the Arab world as a stranger, I was received as a friend—and for this, I feel honored.

Mathias Oppersdorff
Wakefield, Rhode Island
March, 2001

UNDER THE SPELL OF ARABIA

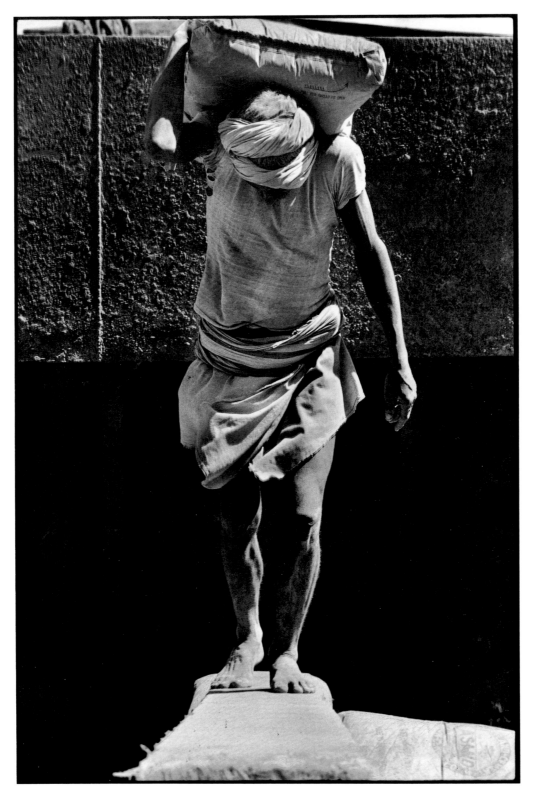

Plate 1

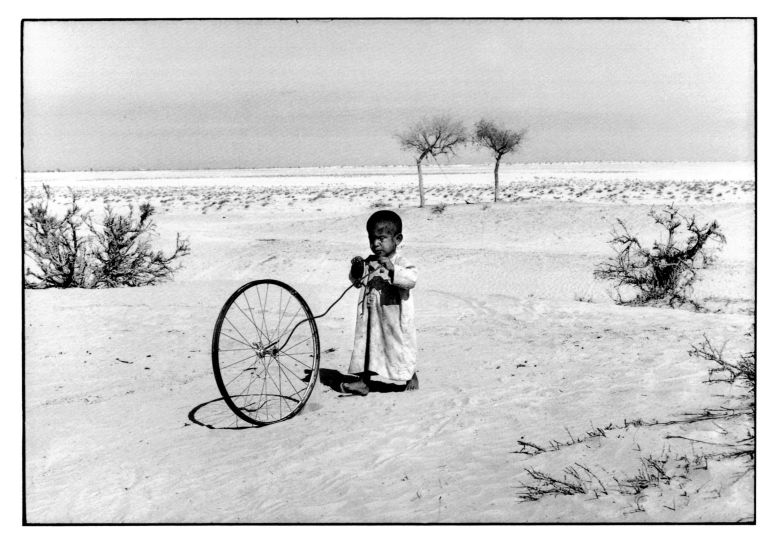

Plate 2

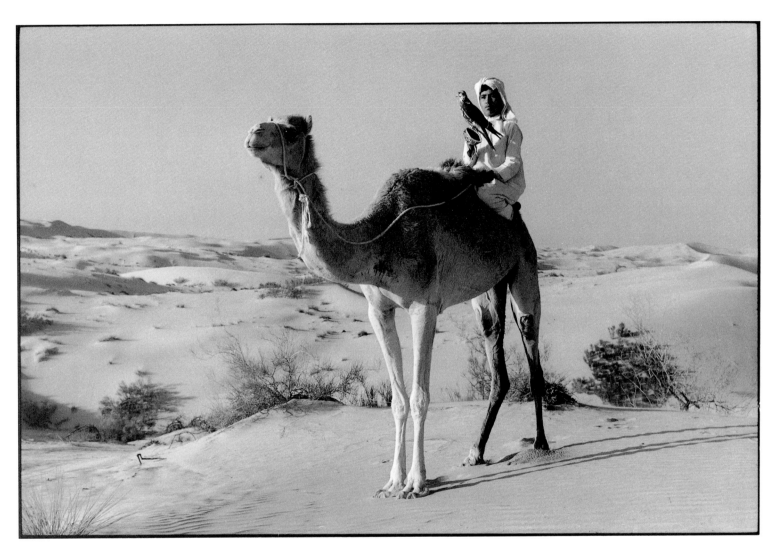

Plate 3

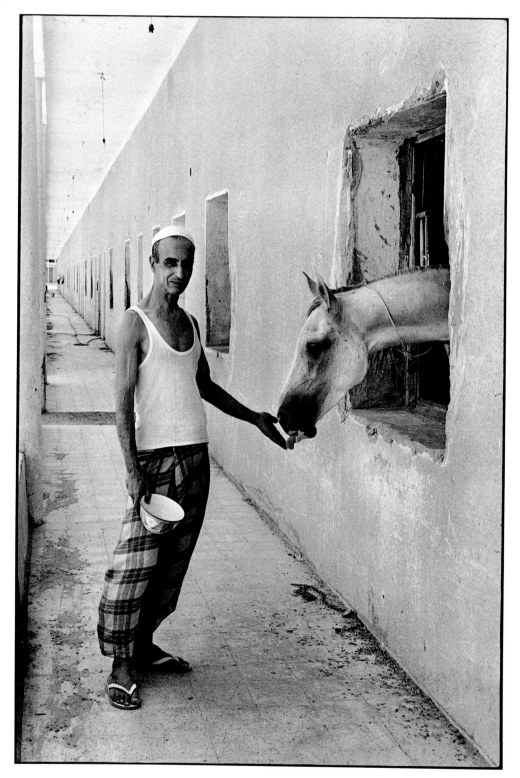

Plate 4

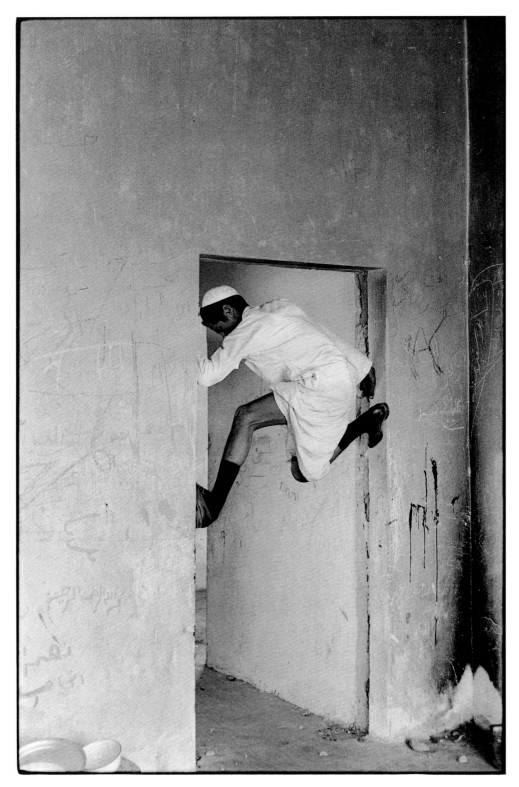

Plate 5

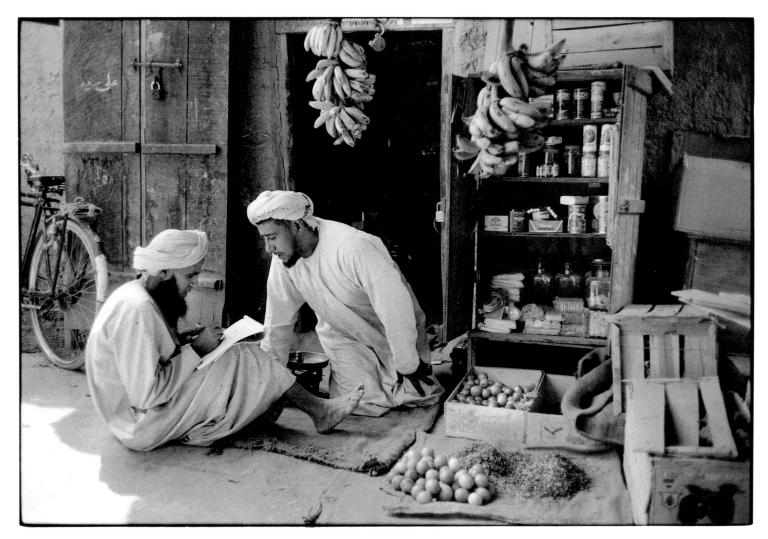

Plate 6

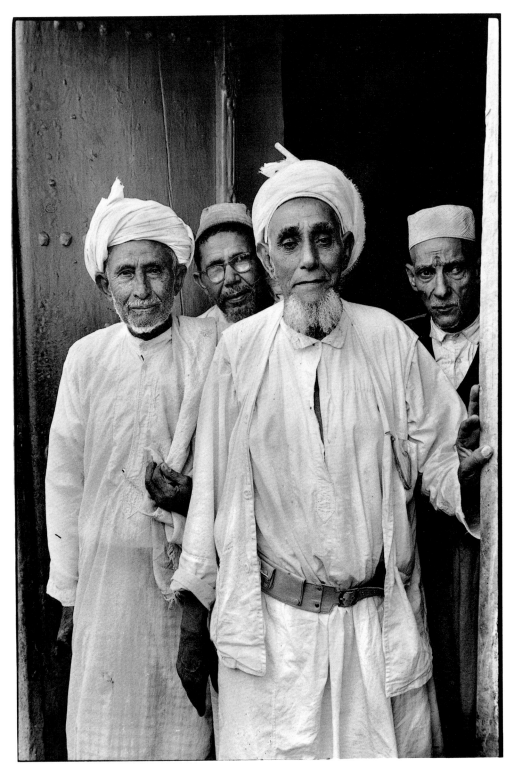

Plate 7

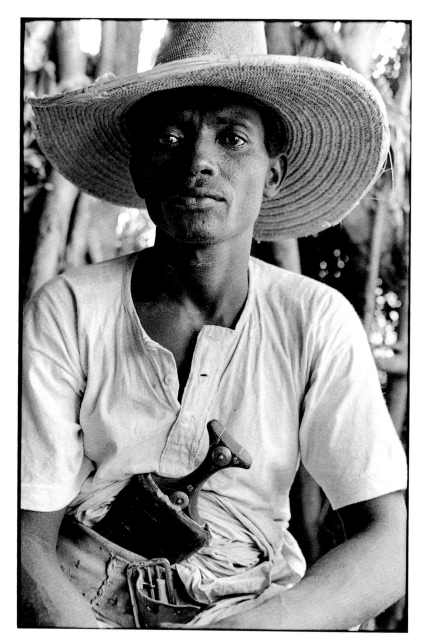

Plate 8

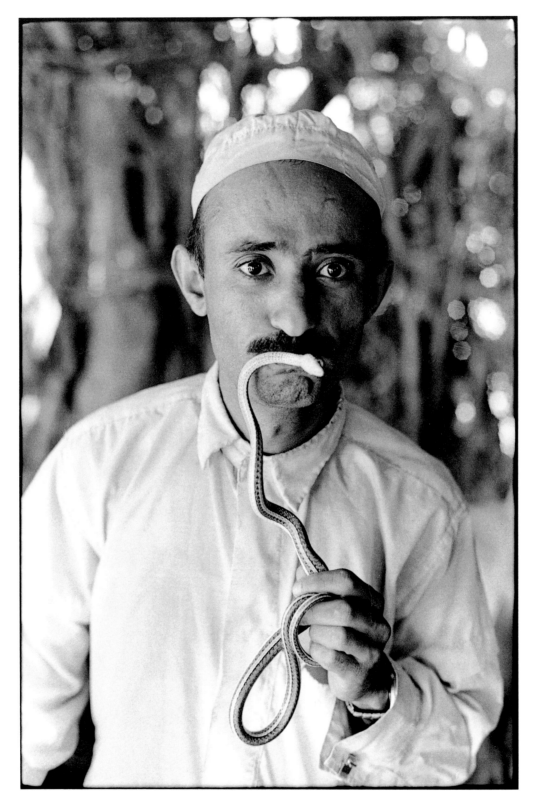

Plate 9

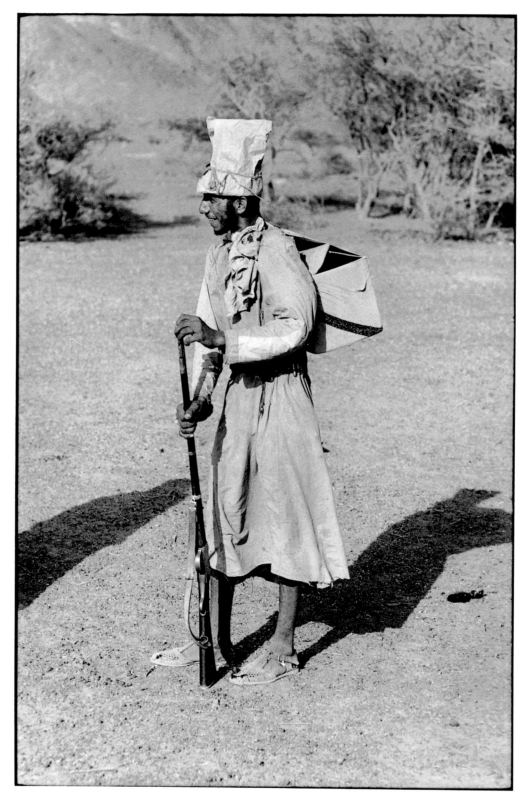

Plate 10

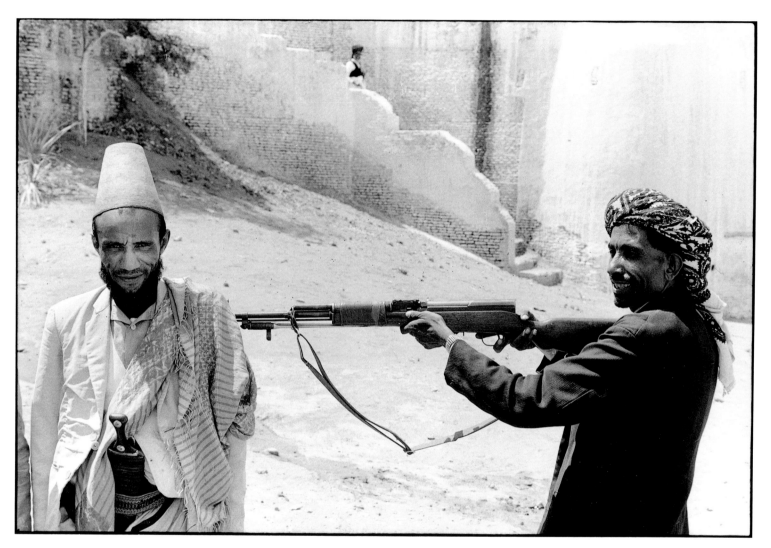

Plate 11

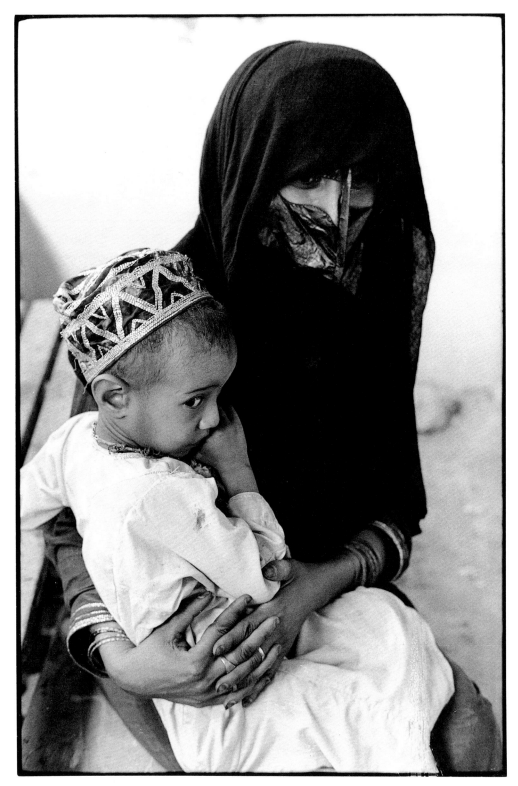

Plate 12

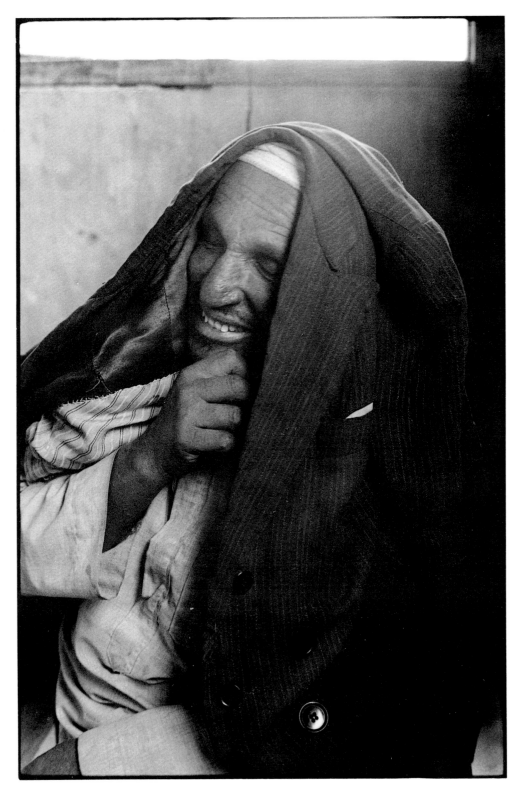

Plate 13

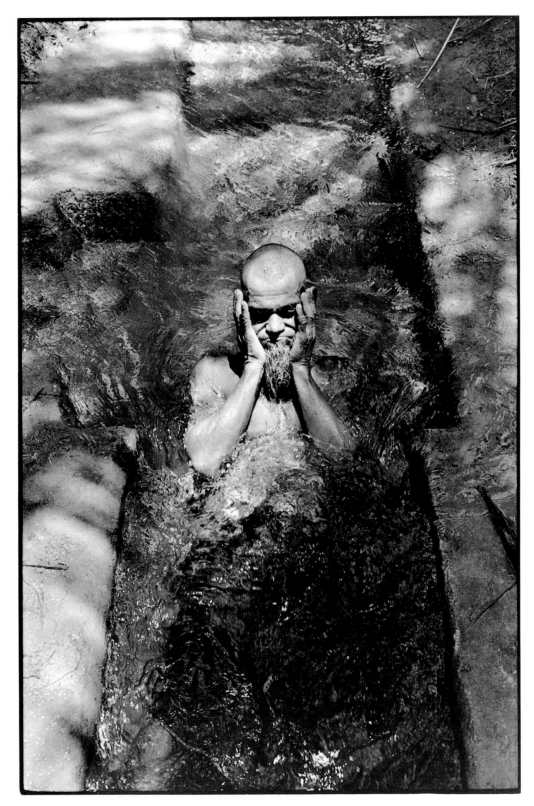

Plate 14

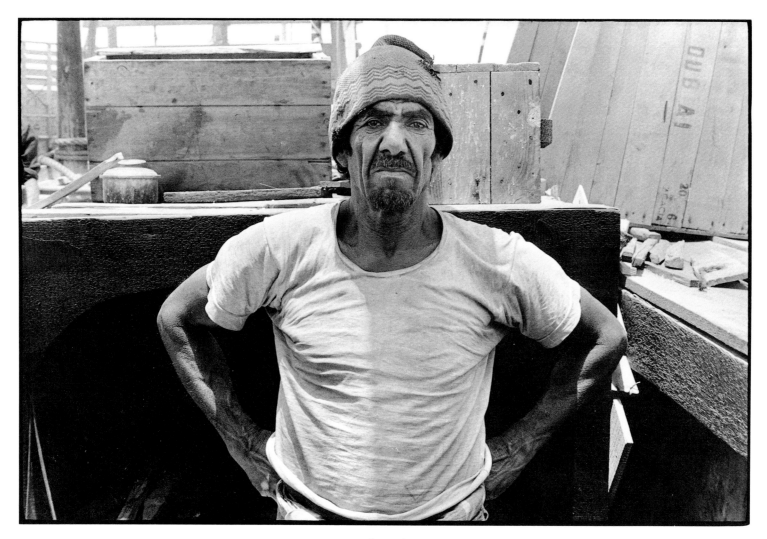

Plate 15

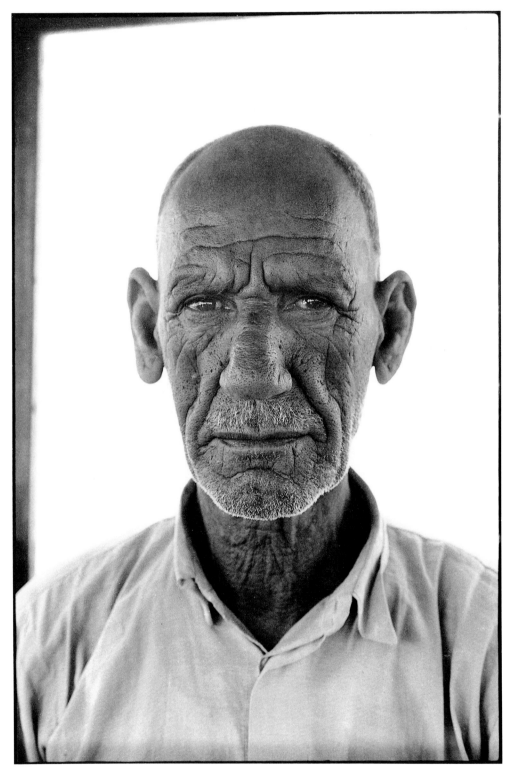

Plate 16

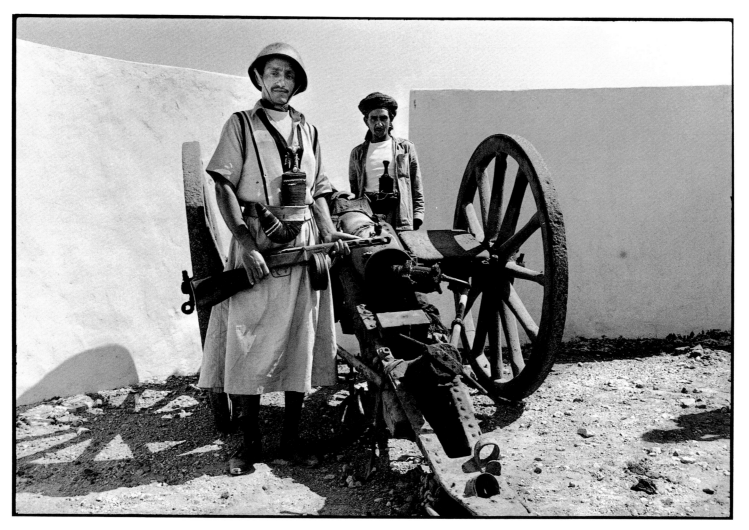

Plate 17

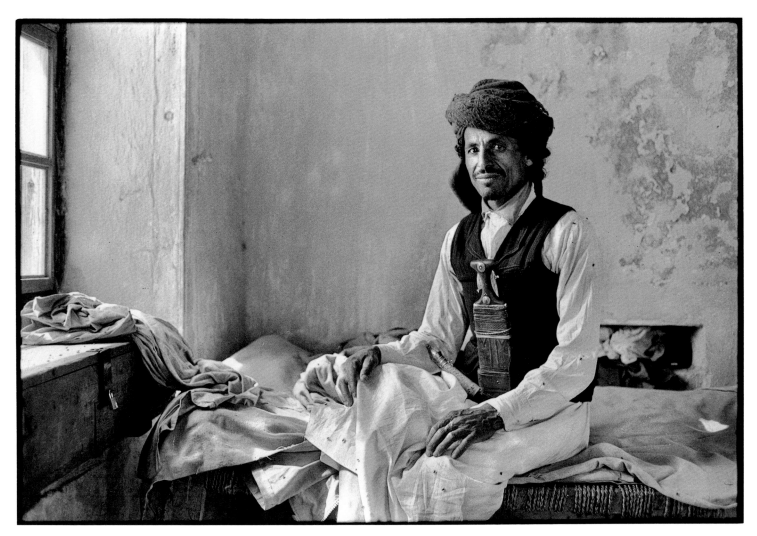

Plate 18

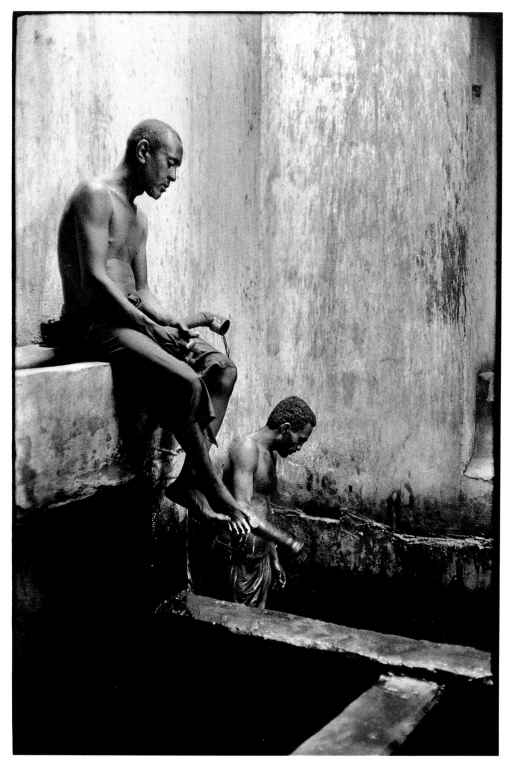

Plate 19

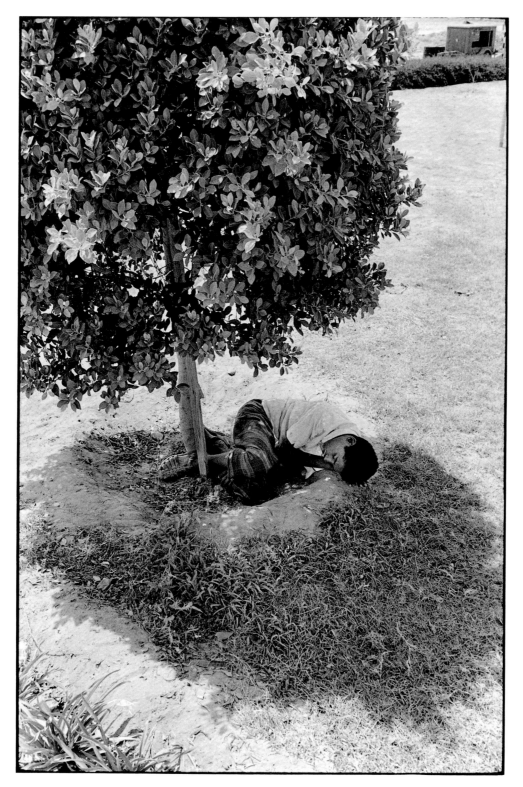

Plate 20

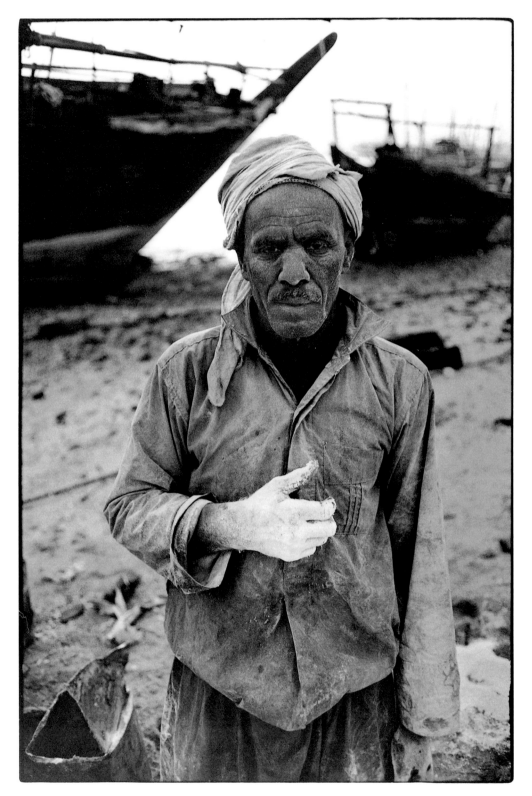

Plate 21

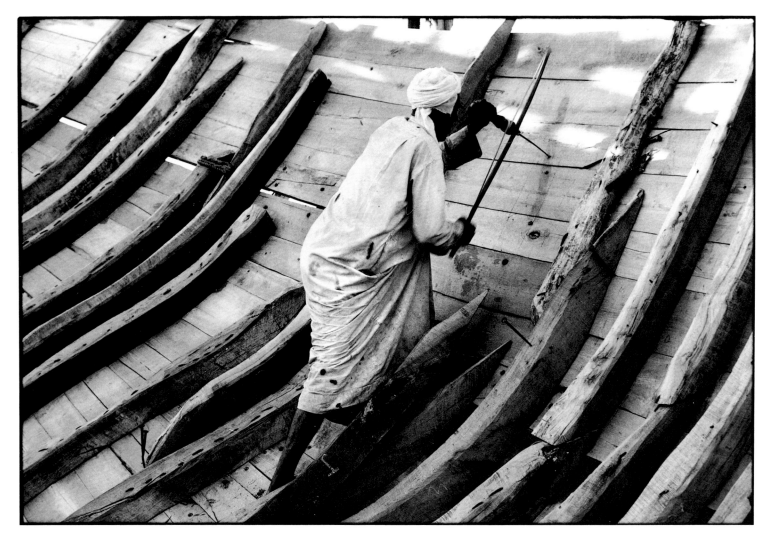

Plate 22

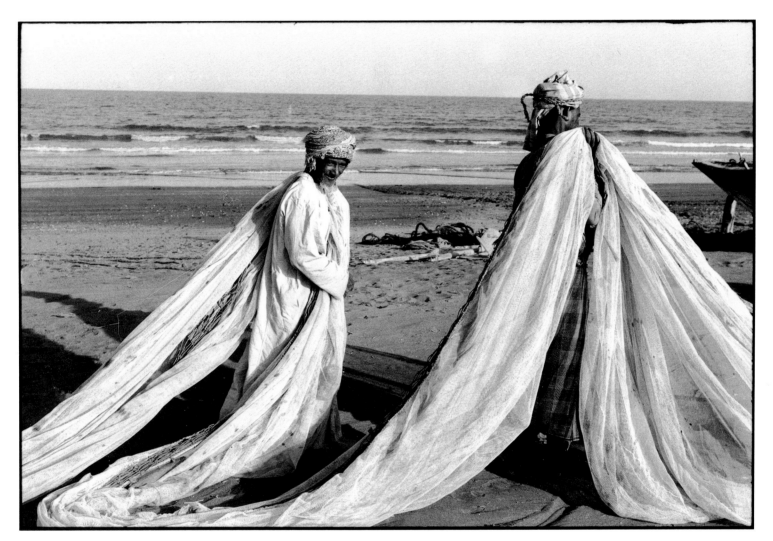

Plate 23

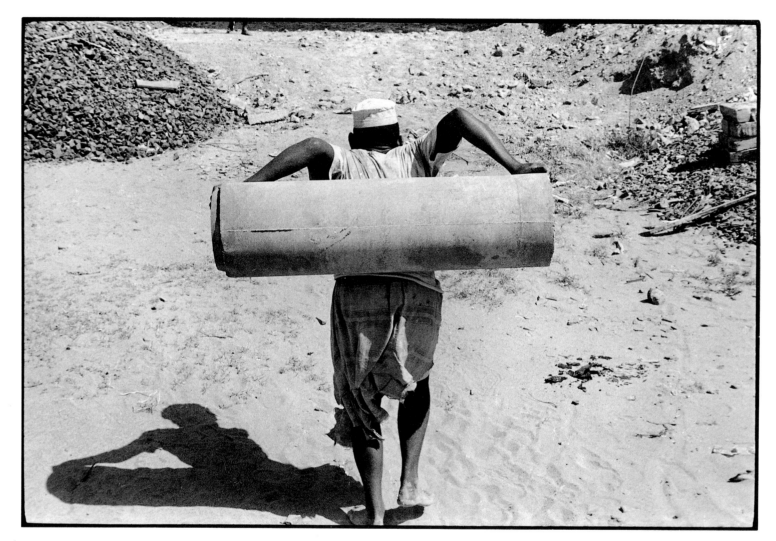

Plate 24

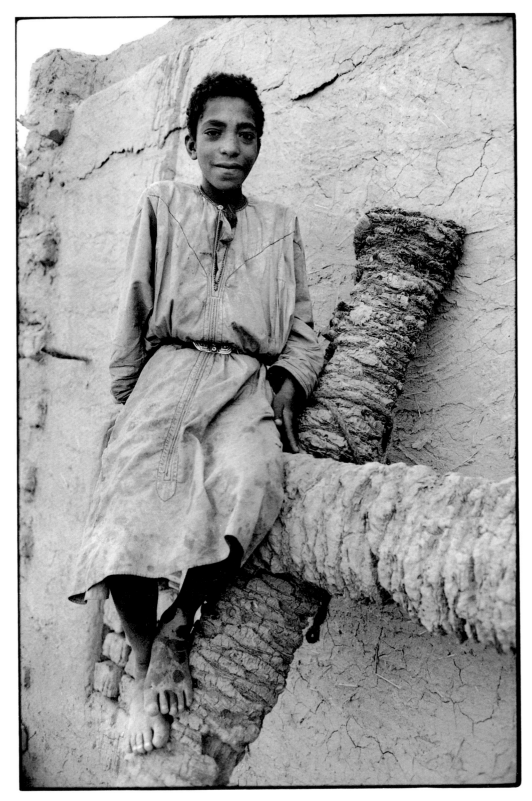

Plate 25

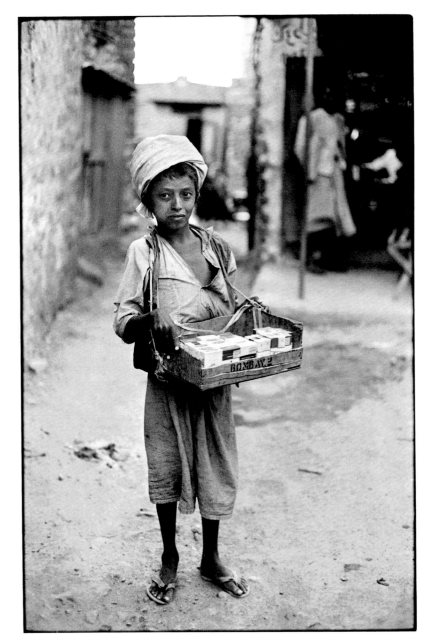

Plate 26

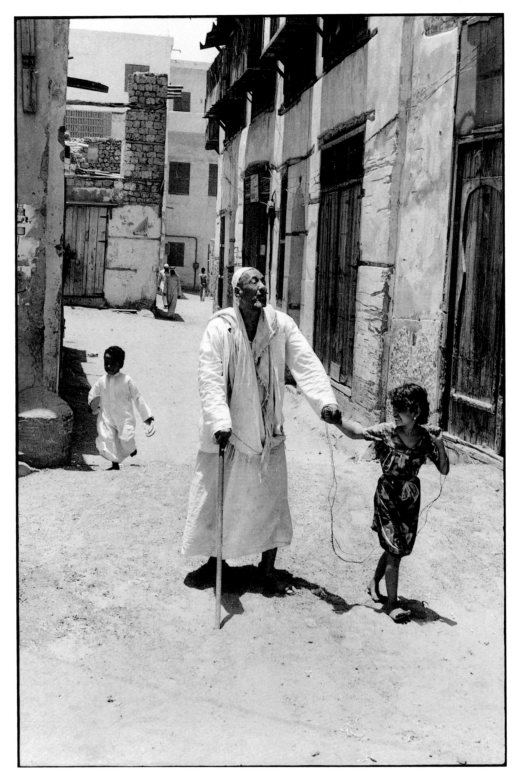

Plate 27

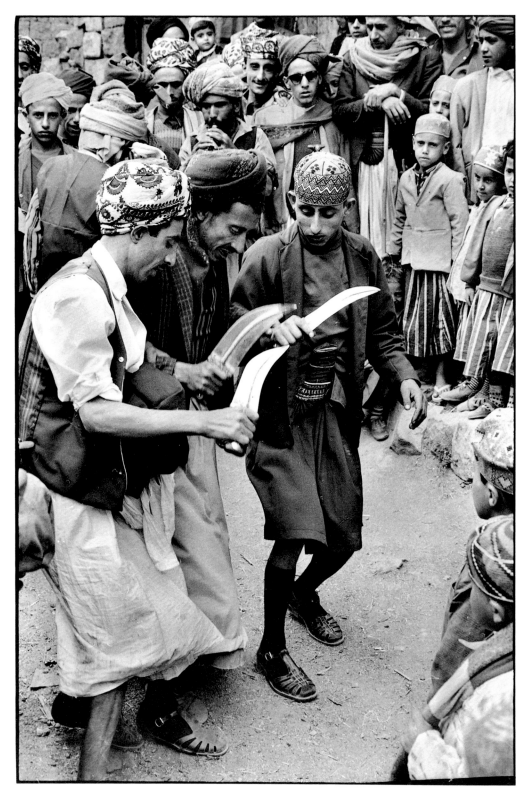

Plate 28

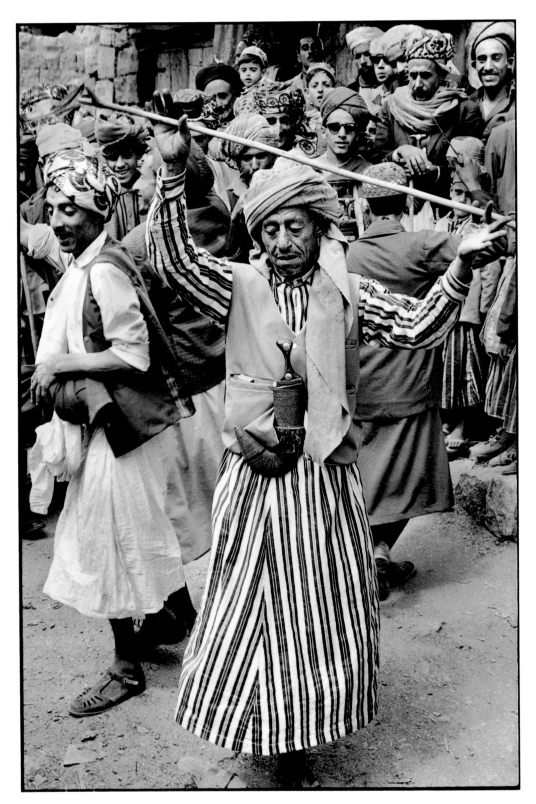

Plate 29

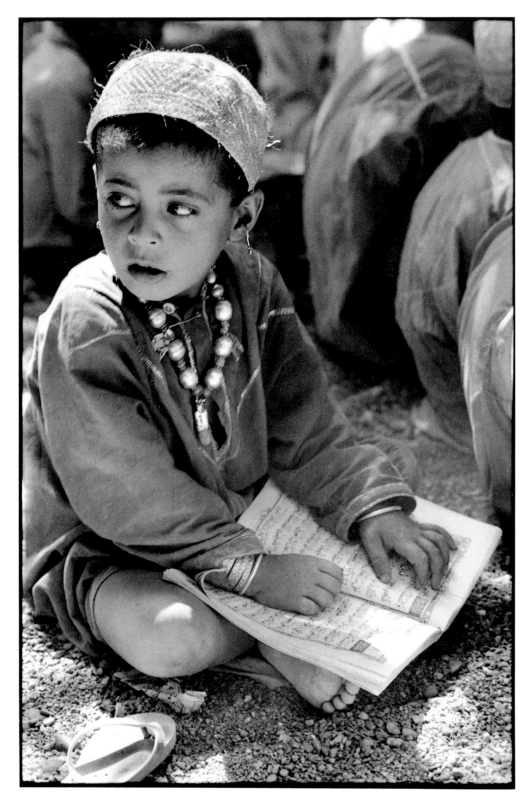

Plate 30

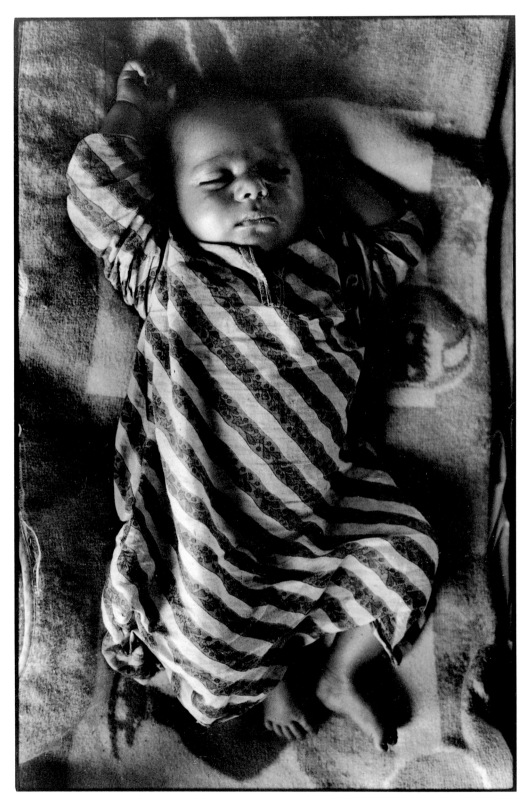

Plate 31

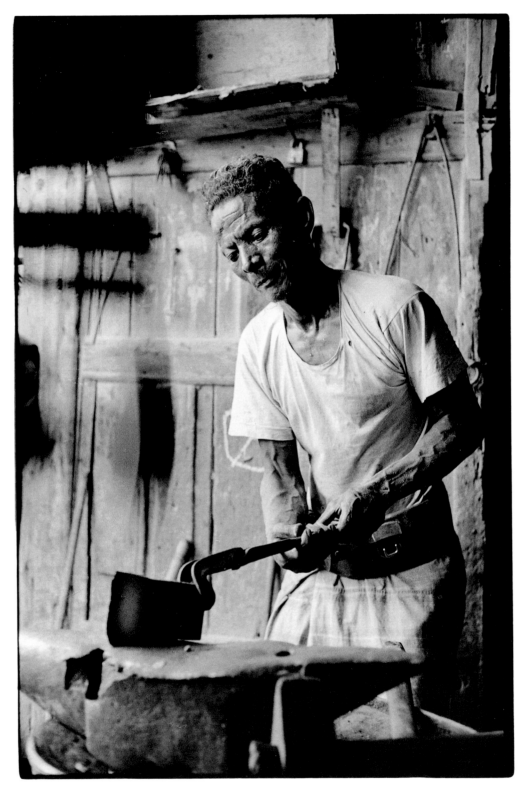

Plate 32

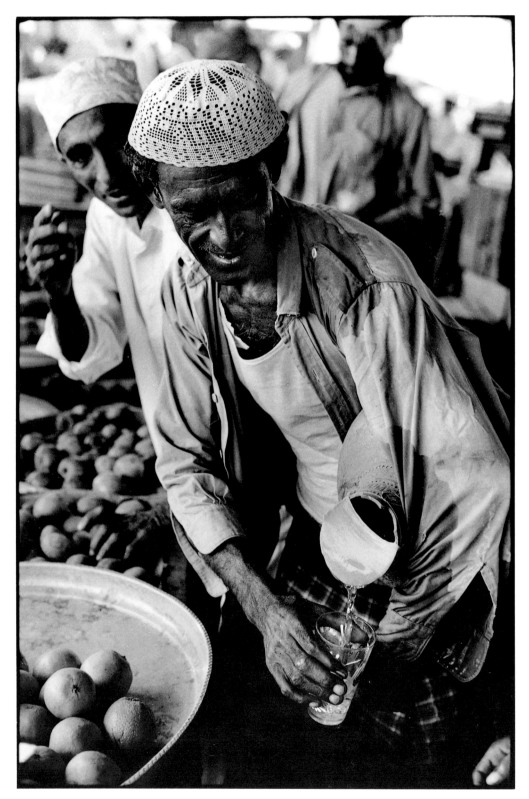

Plate 33

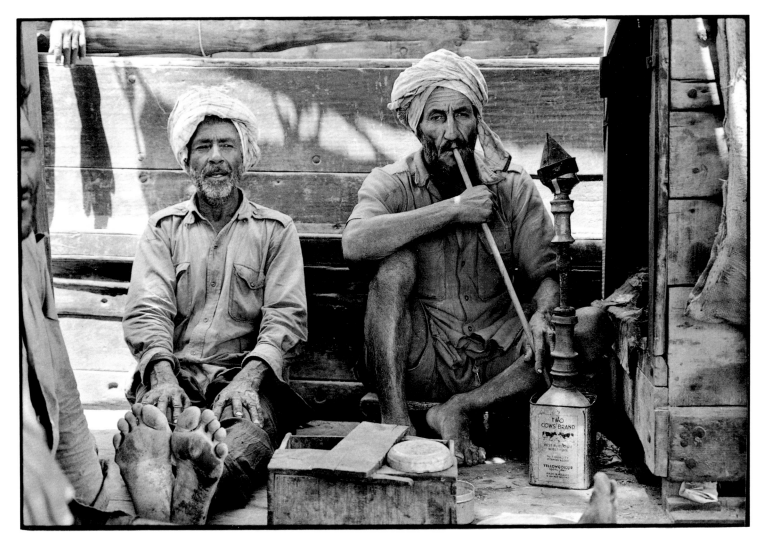

Plate 34

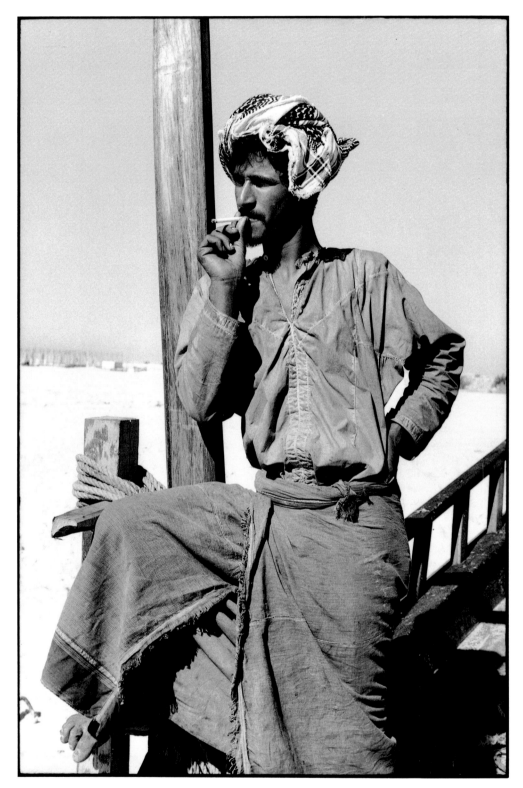

Plate 35

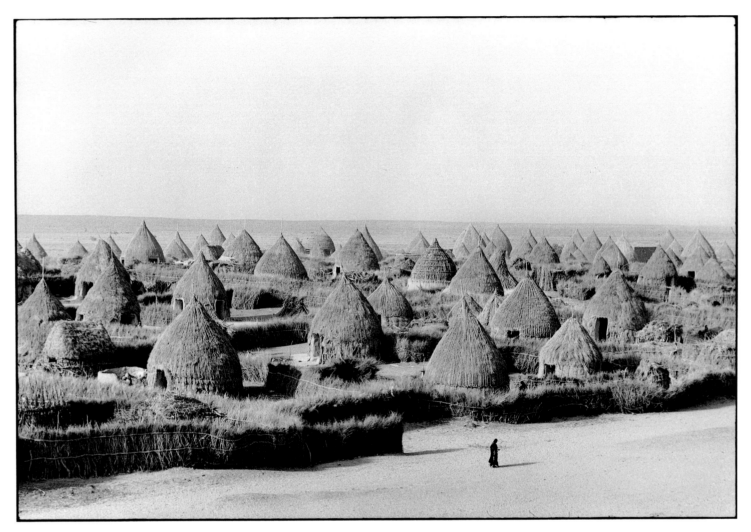

Plate 36

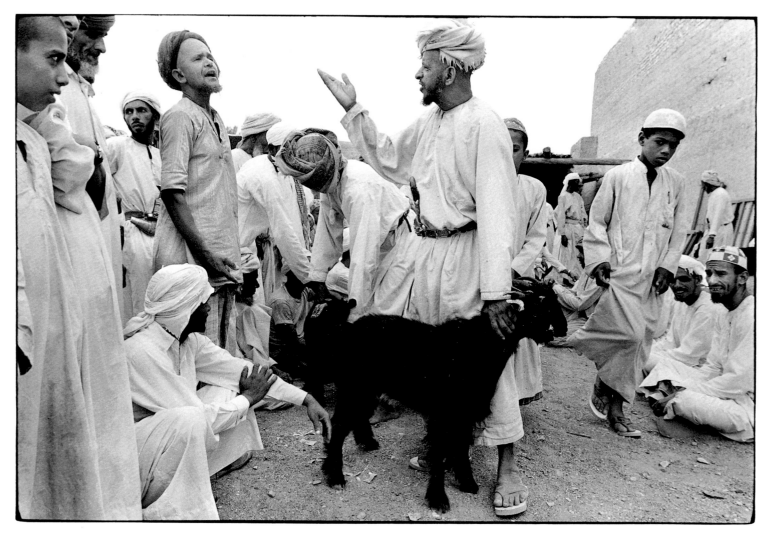

Plate 37

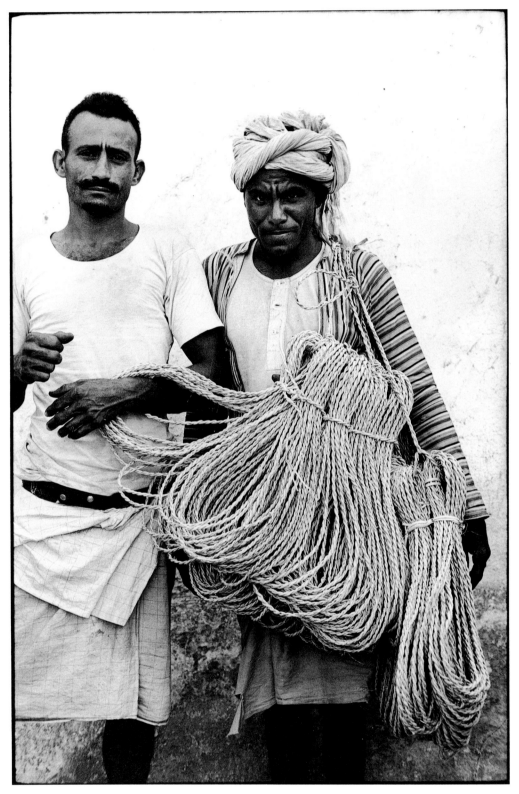

Plate 38

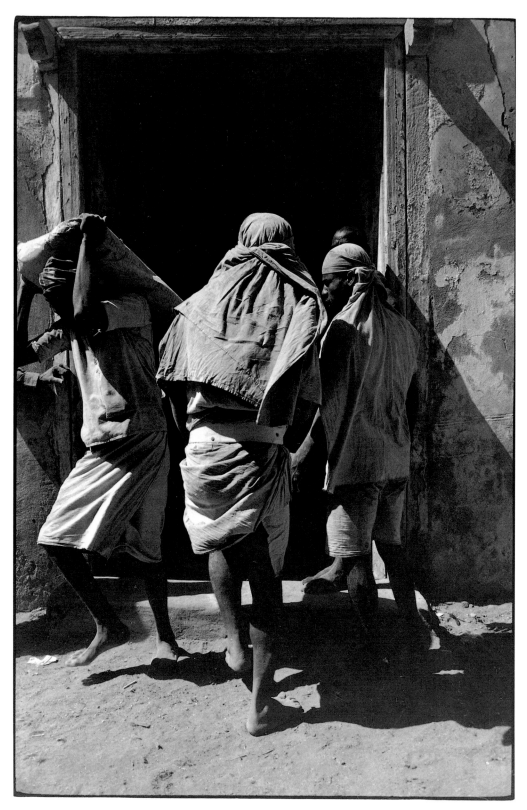

Plate 39

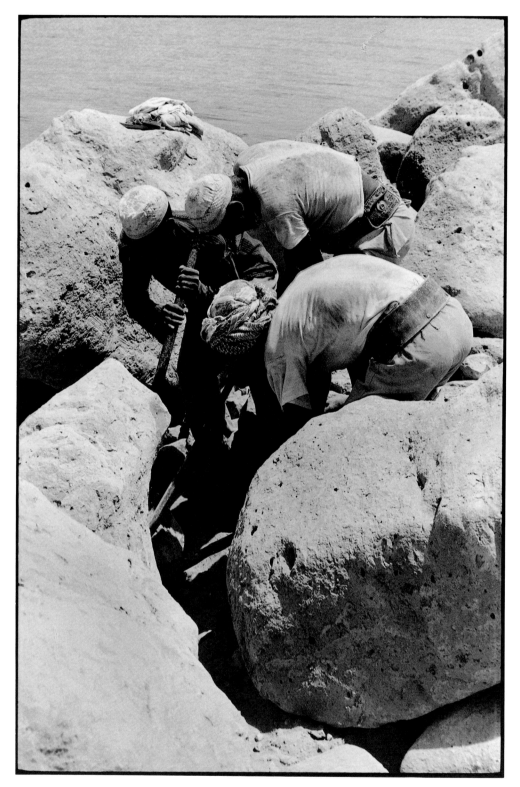

Plate 40

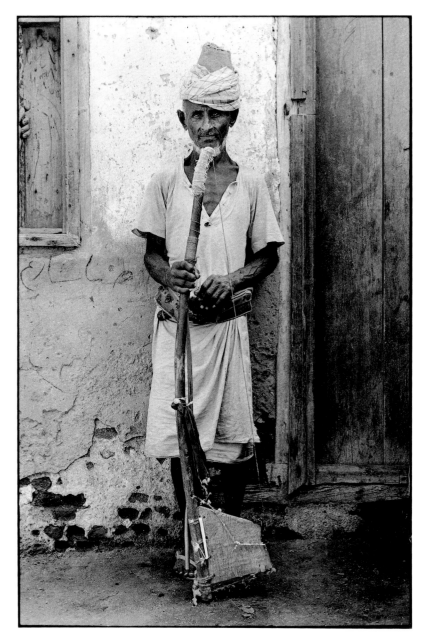

Plate 41

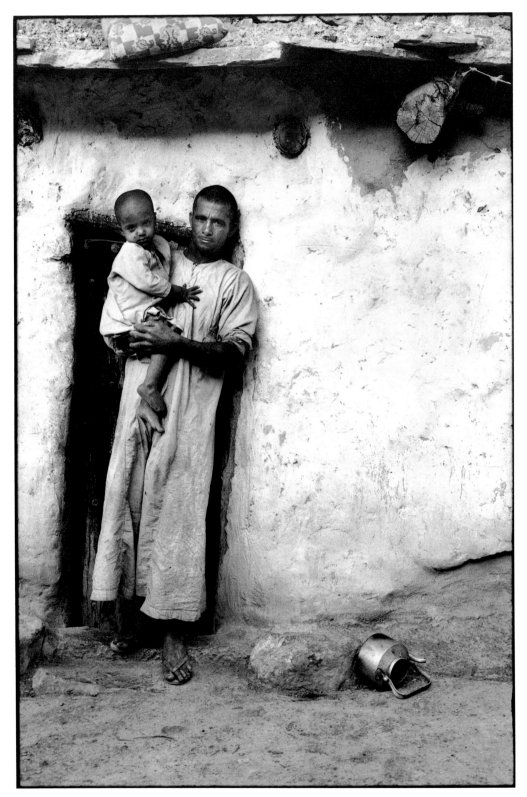

Plate 42

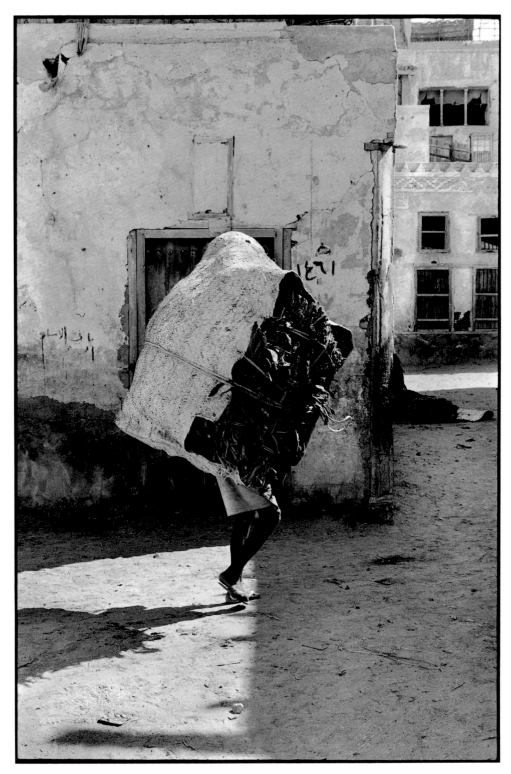

Plate 43

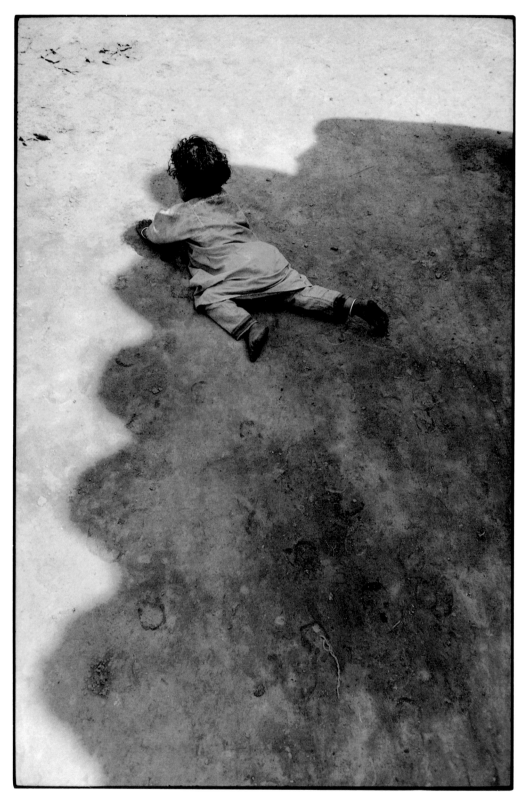

Plate 44

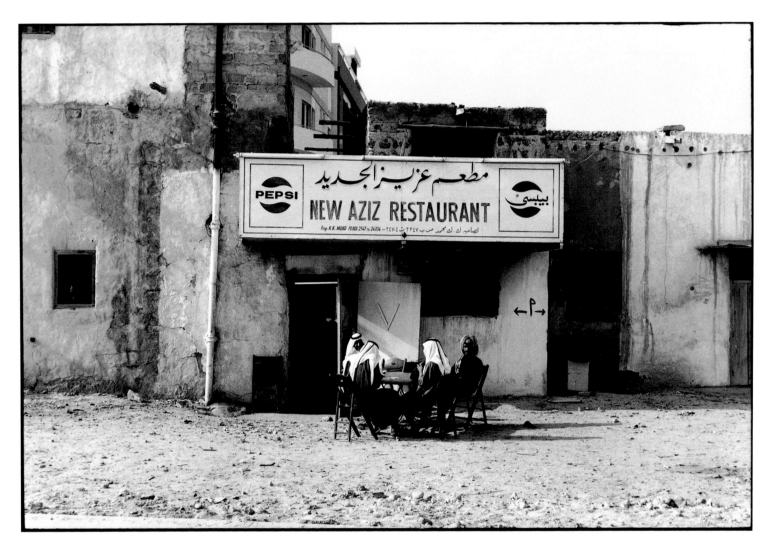

Plate 45

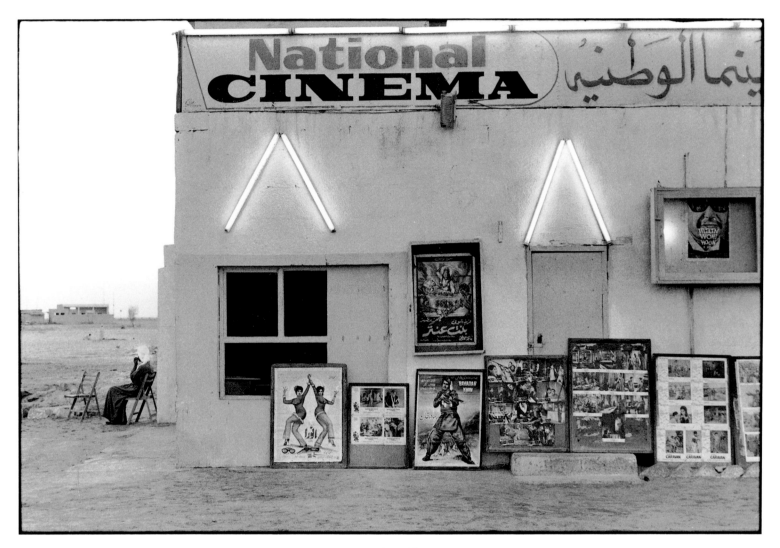

Plate 46

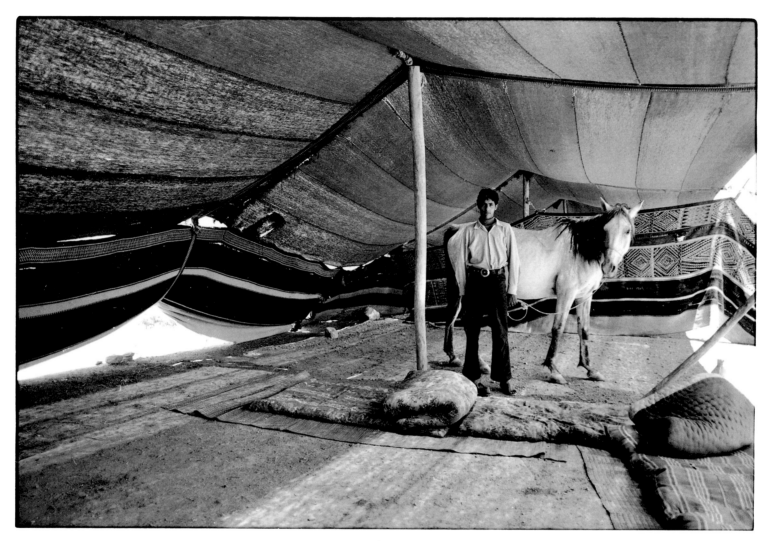

Plate 47

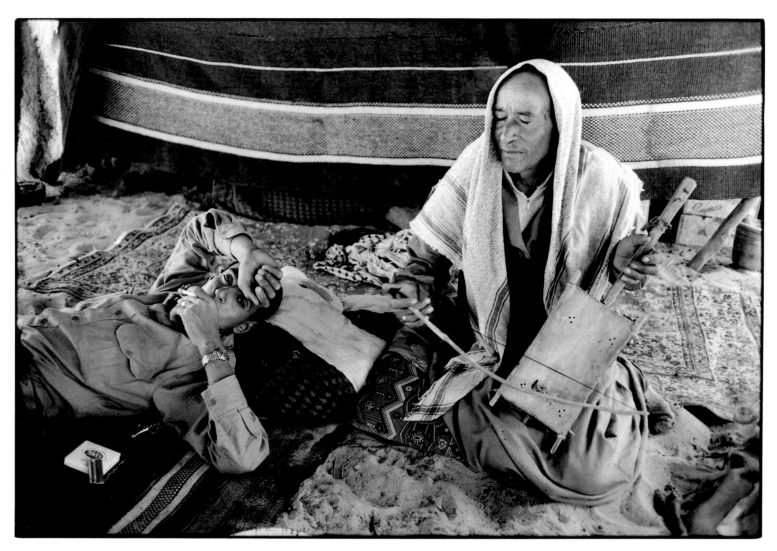

Plate 48

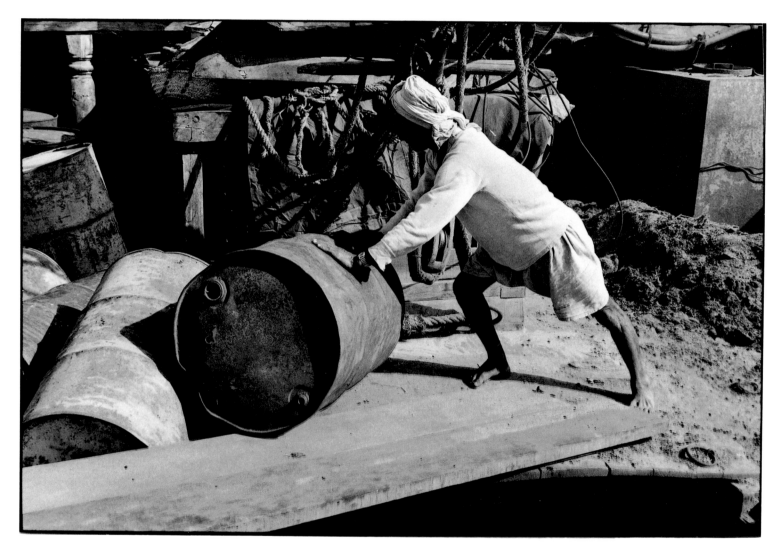

Plate 49

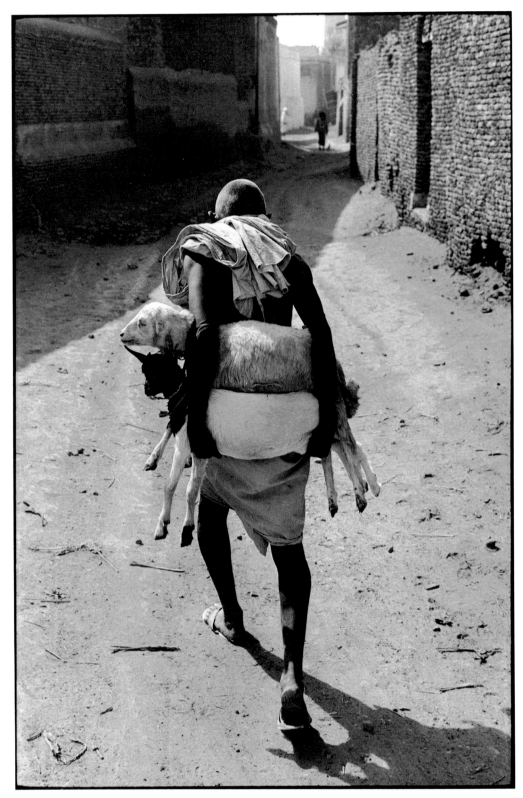

Plate 50

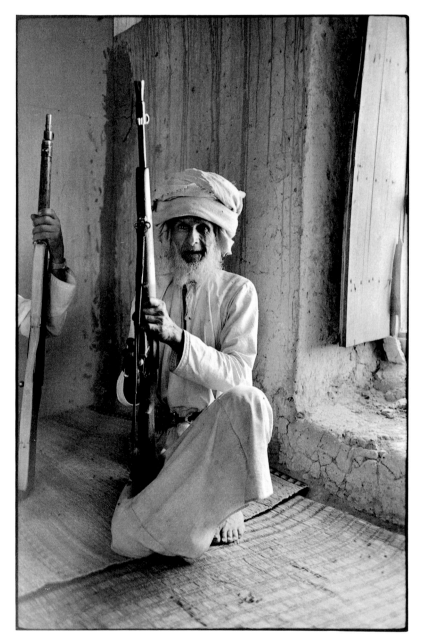

Plate 51

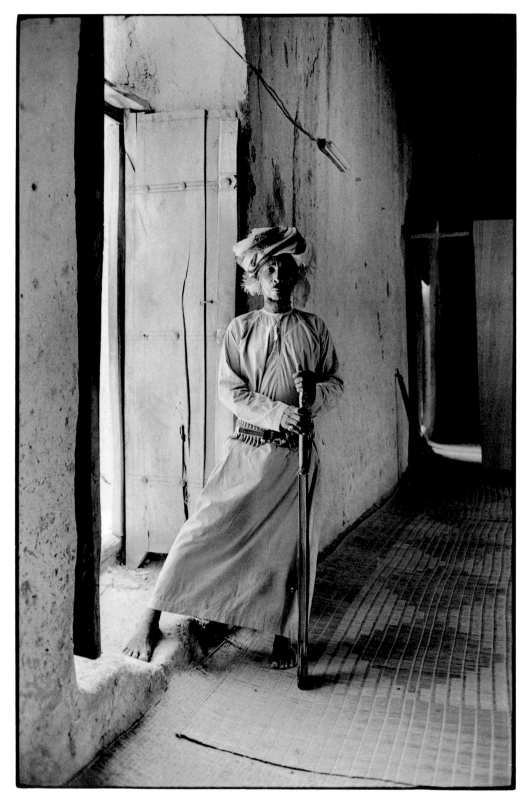

Plate 52

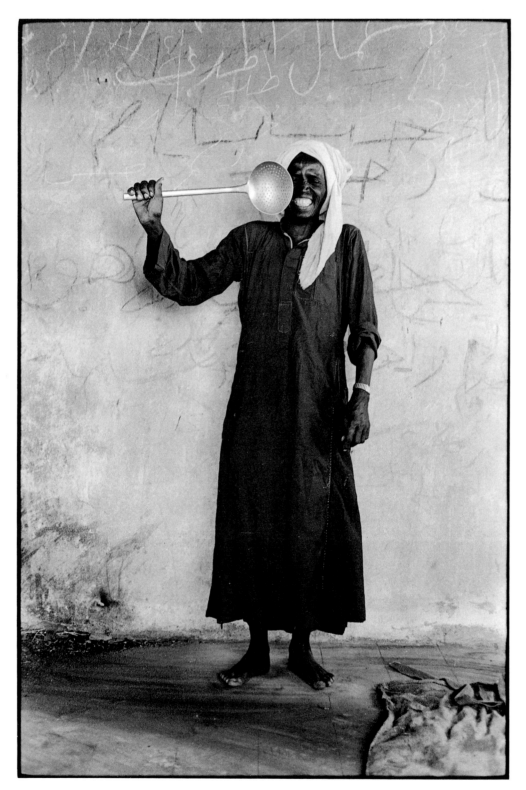

Plate 53

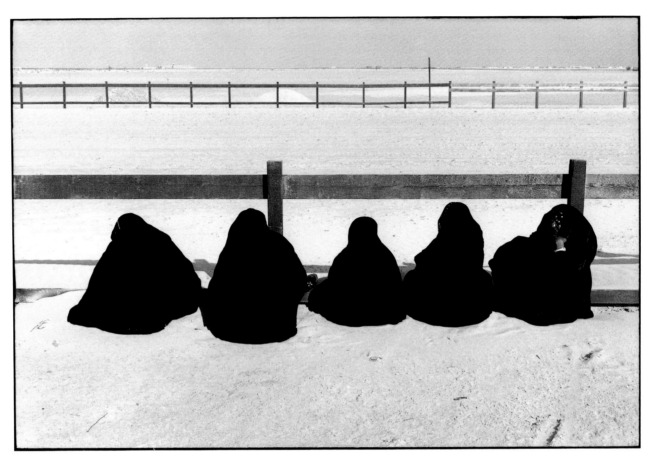

Plate 54

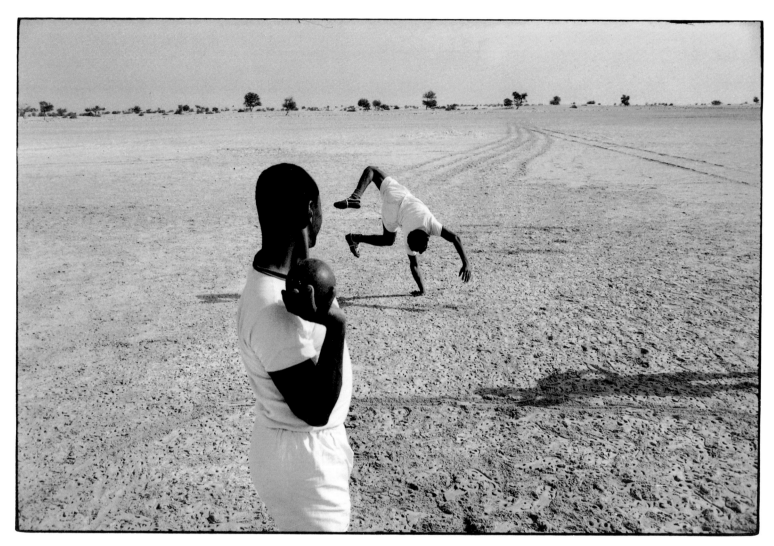

Plate 55

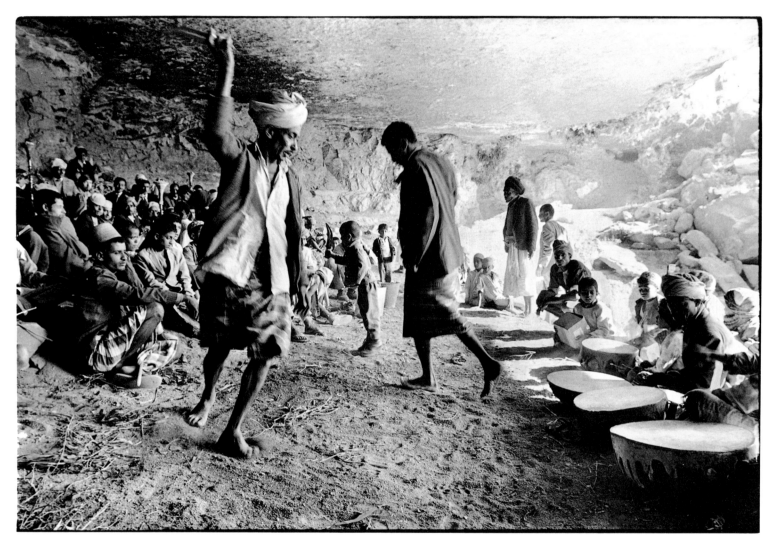

Plate 56

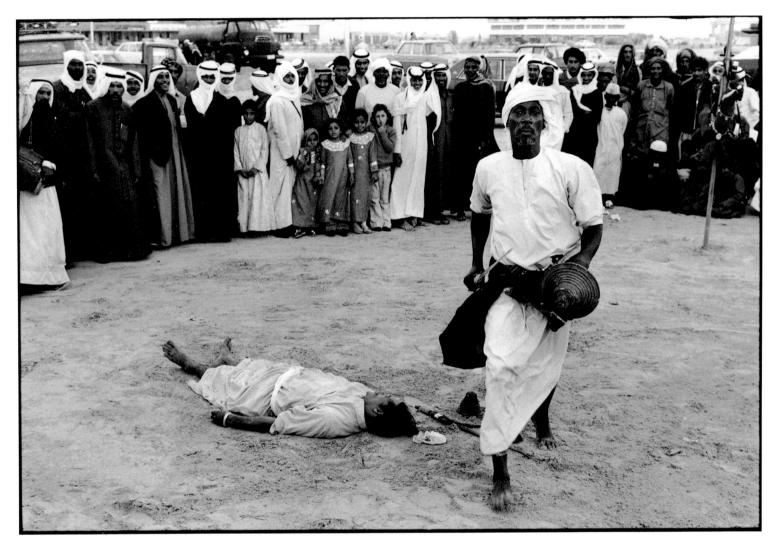

Plate 57

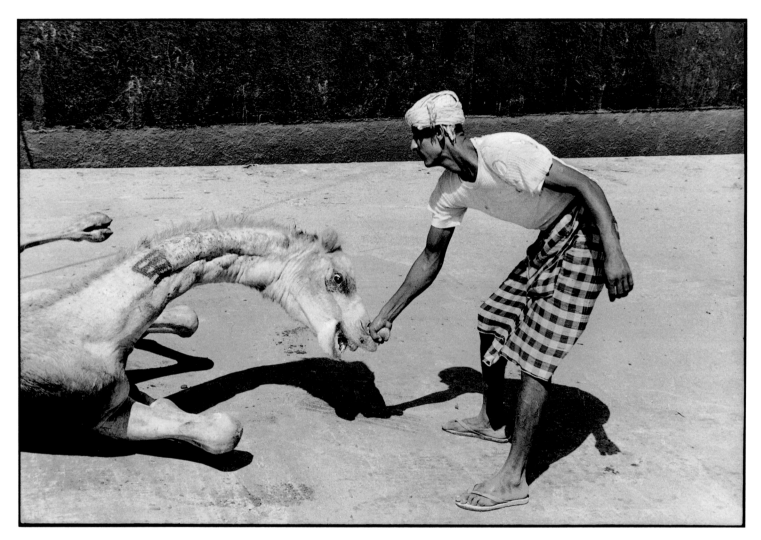

Plate 58

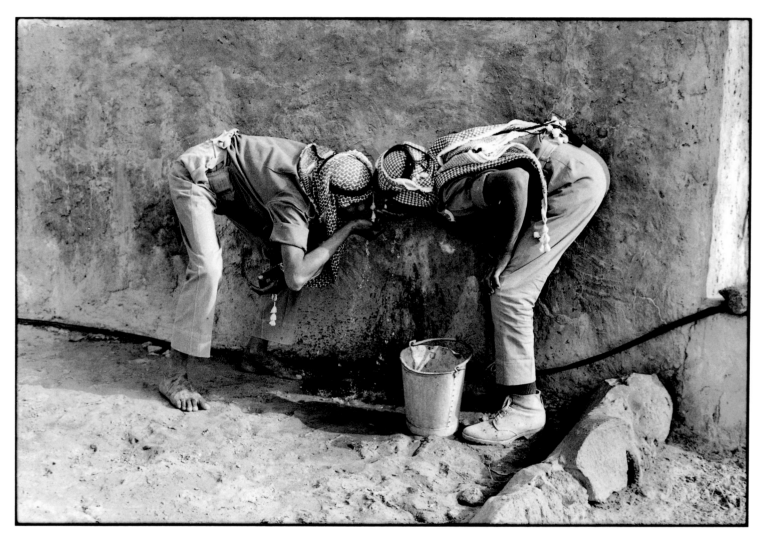

Plate 59

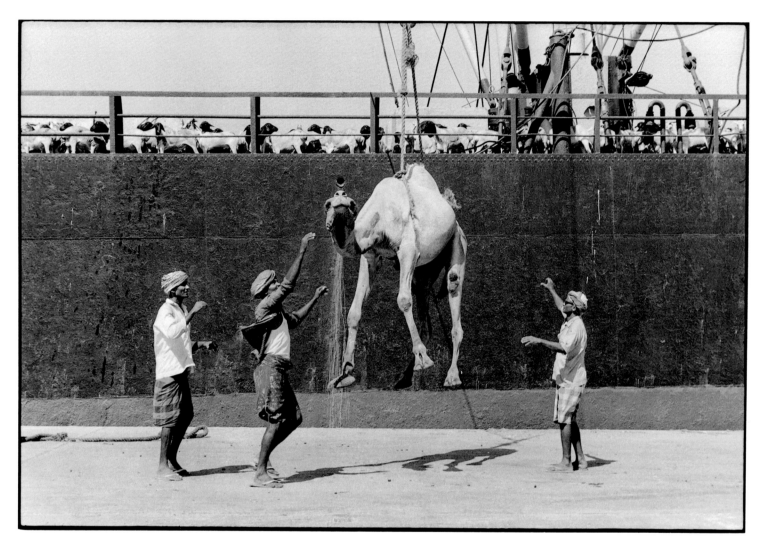

Plate 60

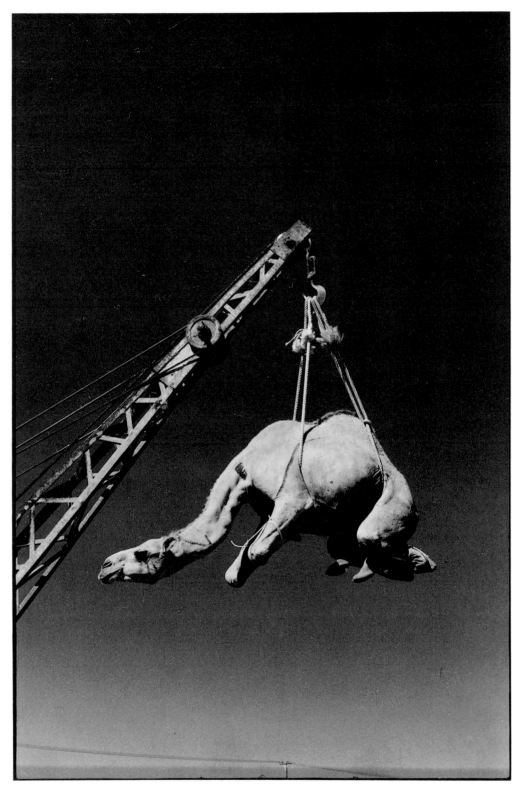

Plate 61

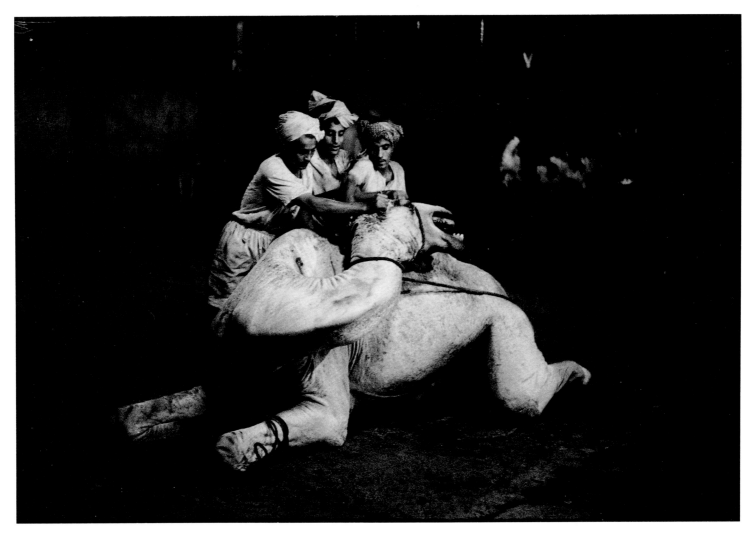

Plate 62

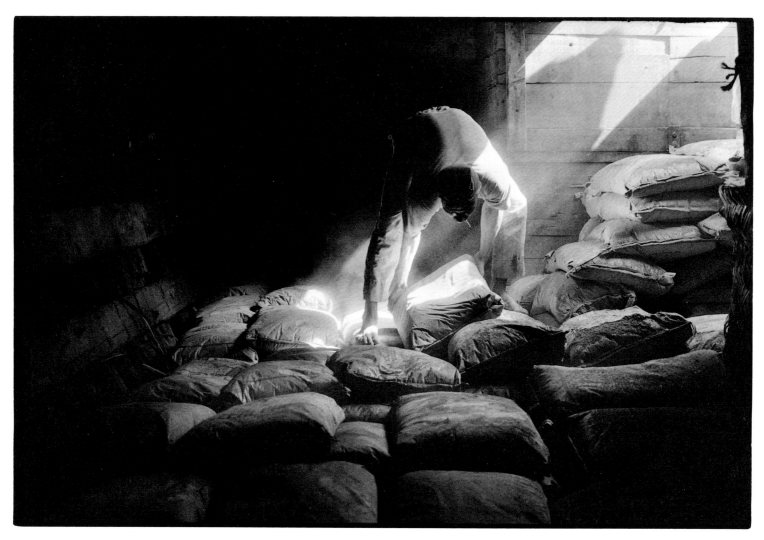

Plate 63

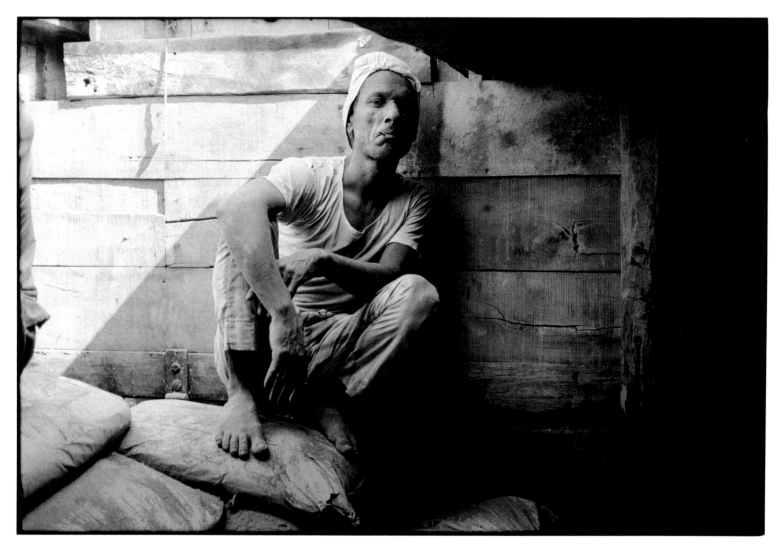

Plate 64

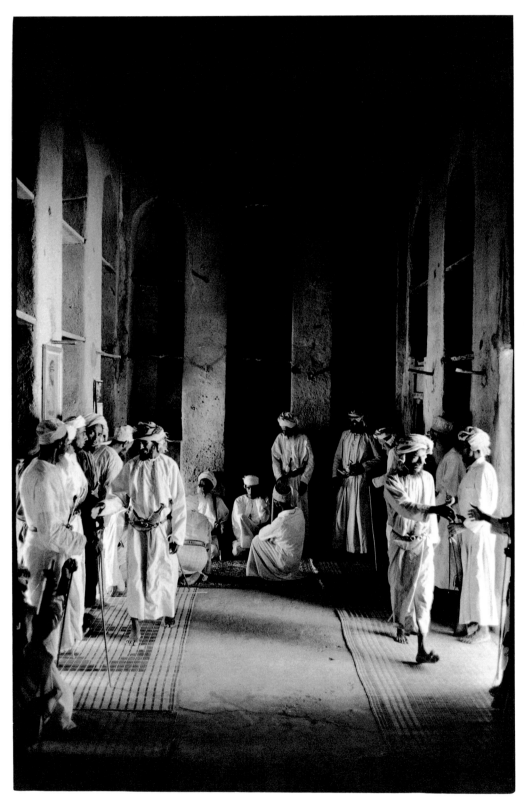

Plate 65

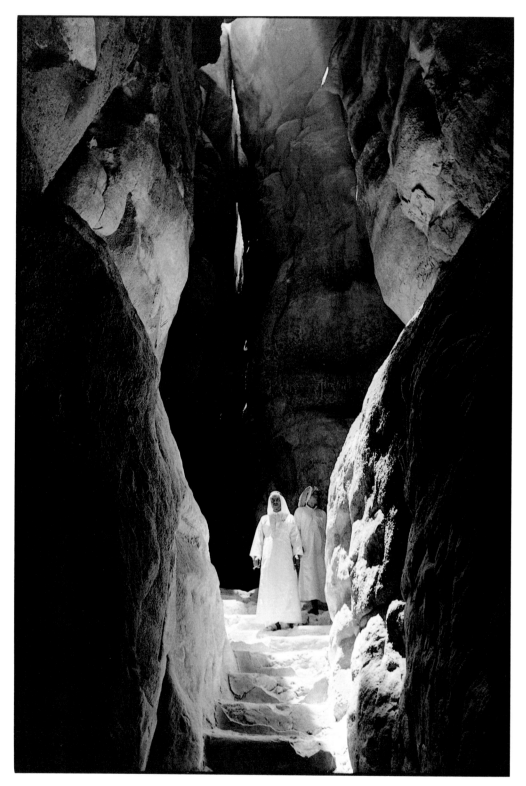

Plate 66

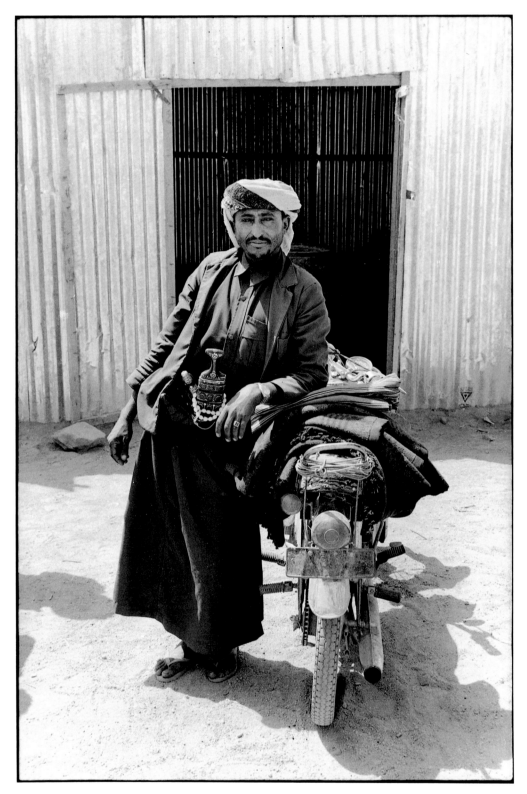

Plate 67

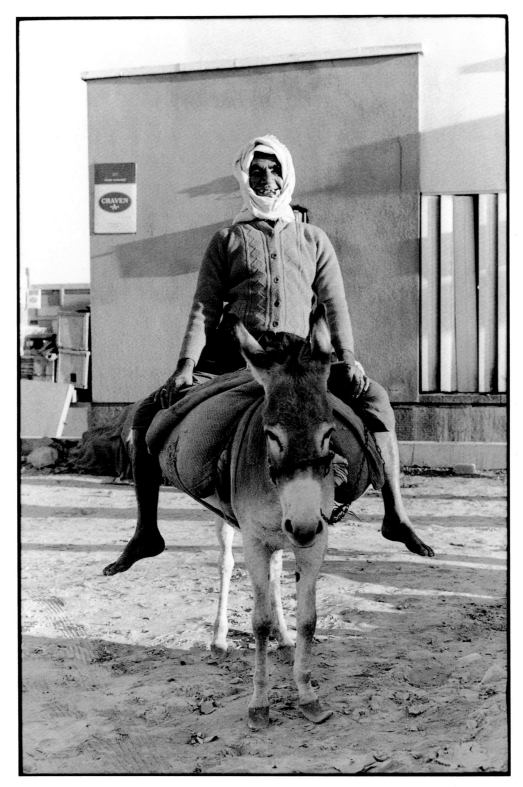

Plate 68

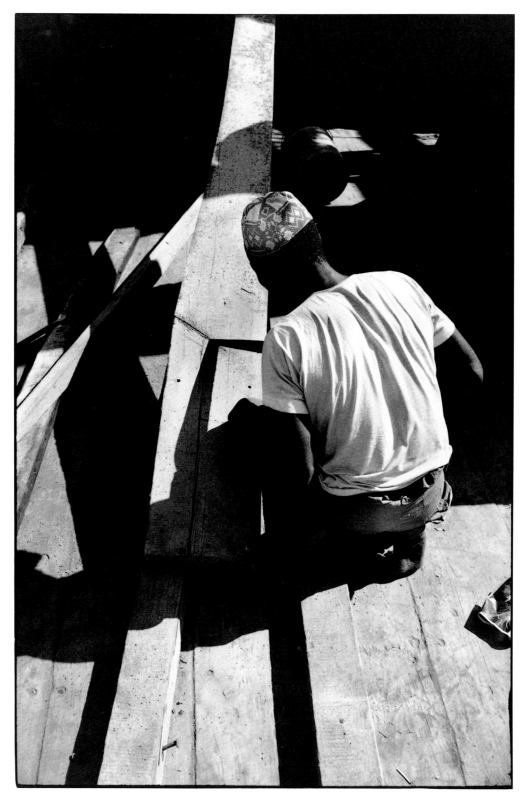

Plate 69

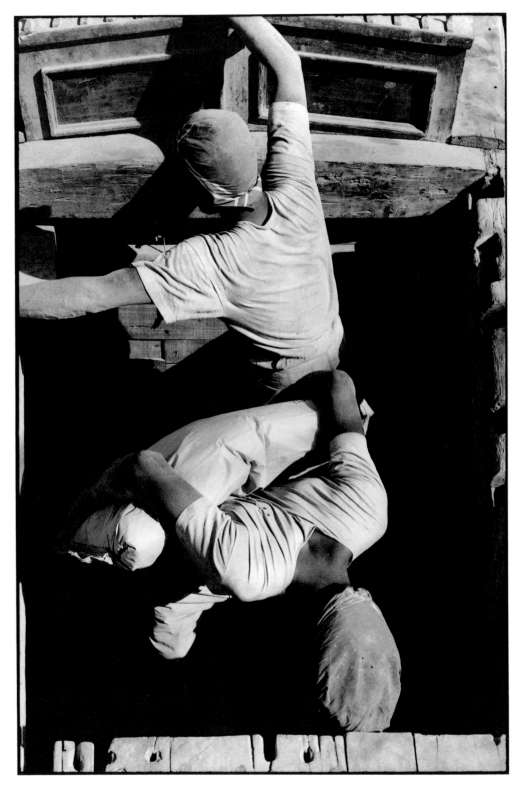

Plate 70

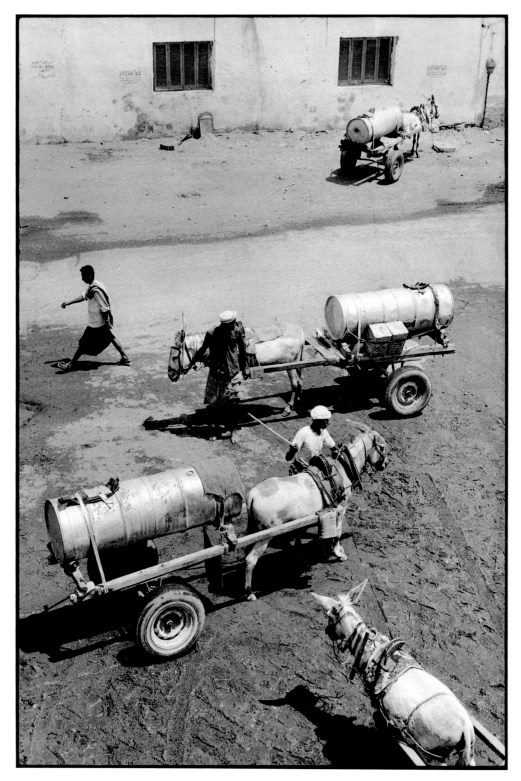

Plate 71

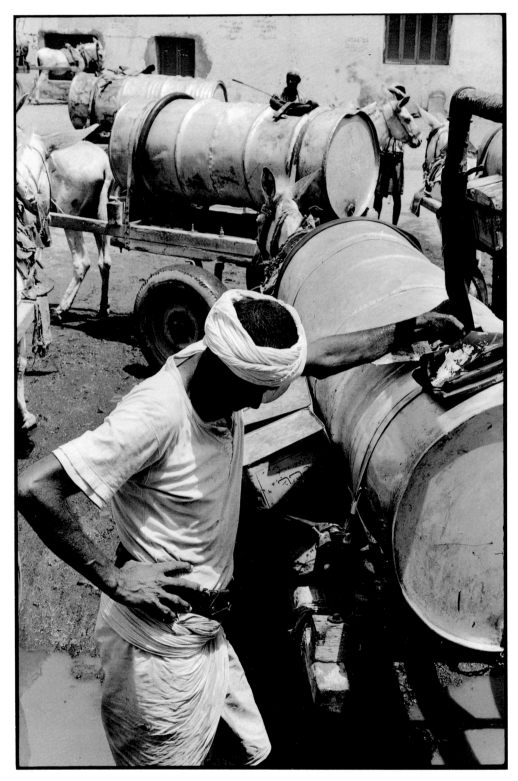

Plate 72

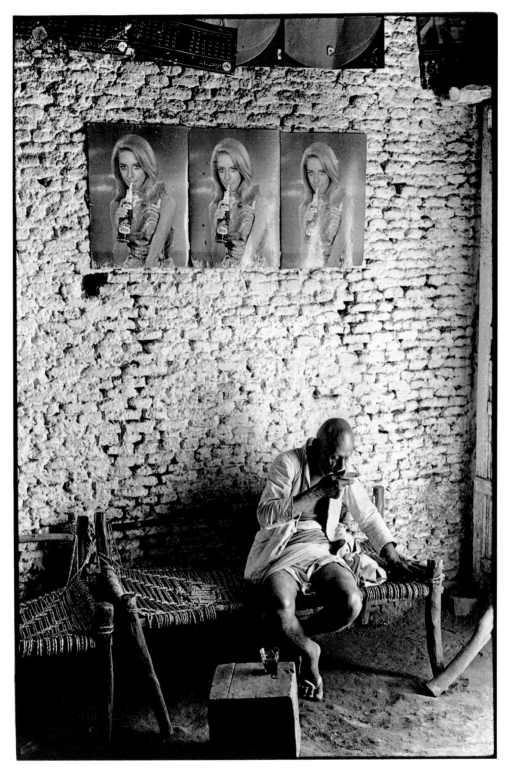

Plate 73

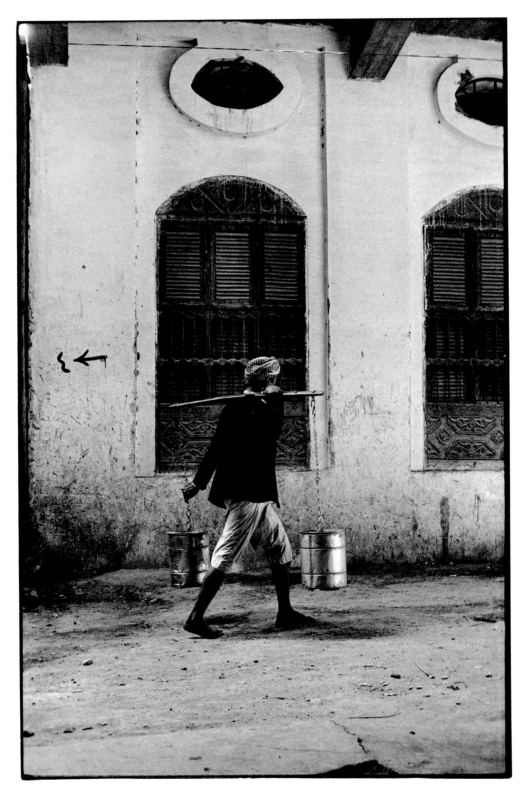

Plate 74

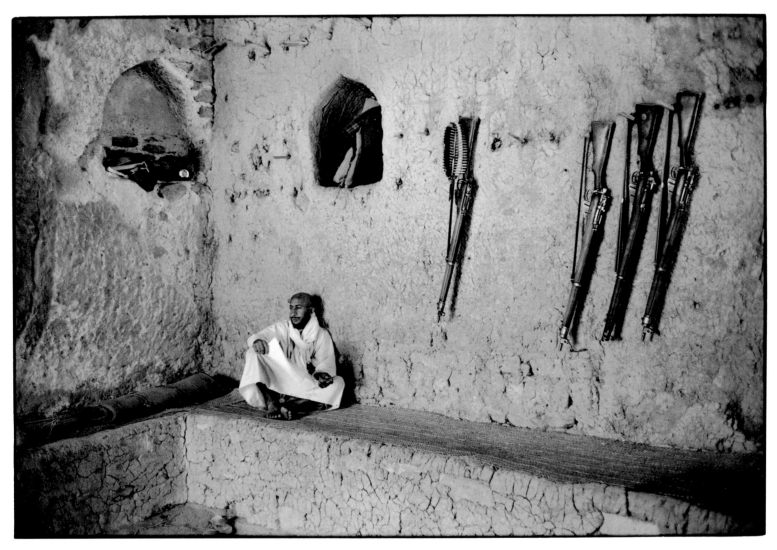

Plate 75

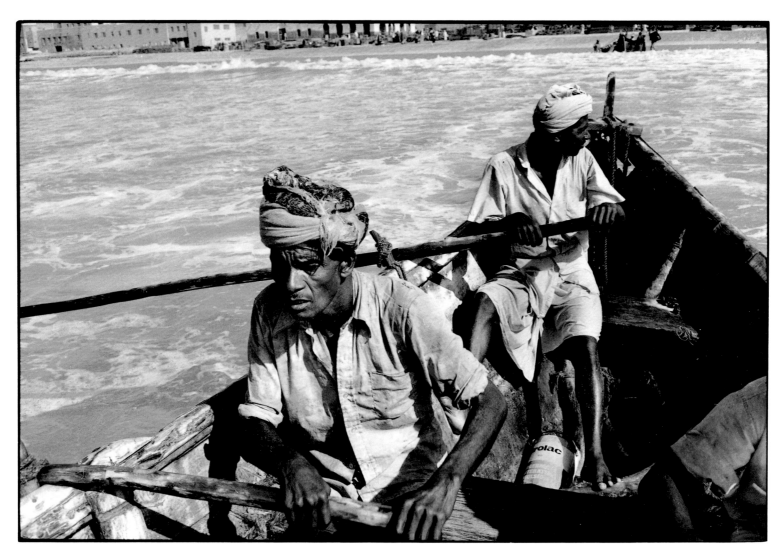

Plate 76

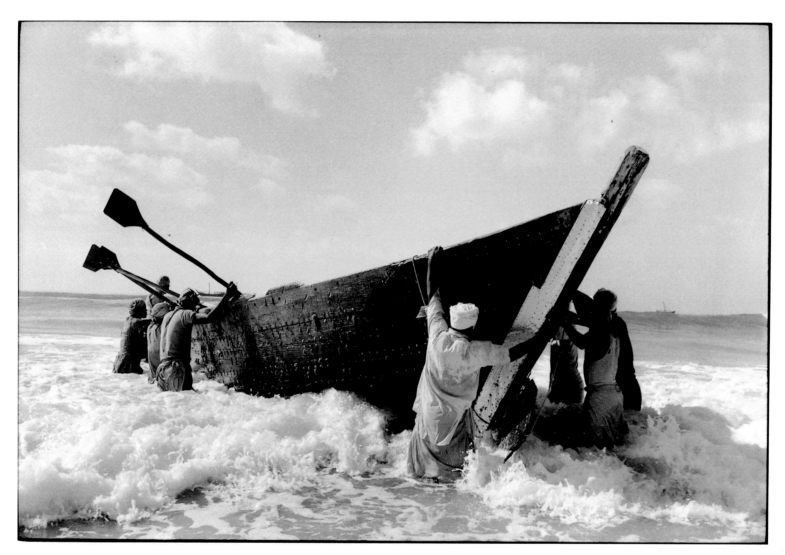

Plate 77

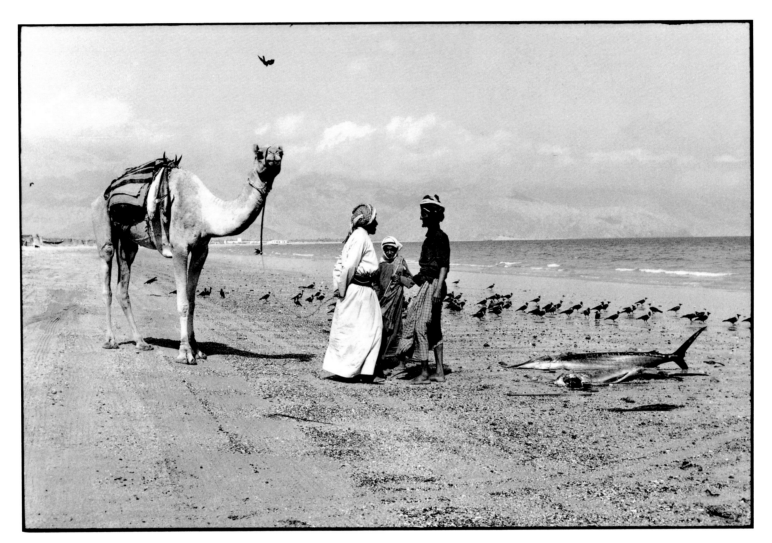

Plate 78

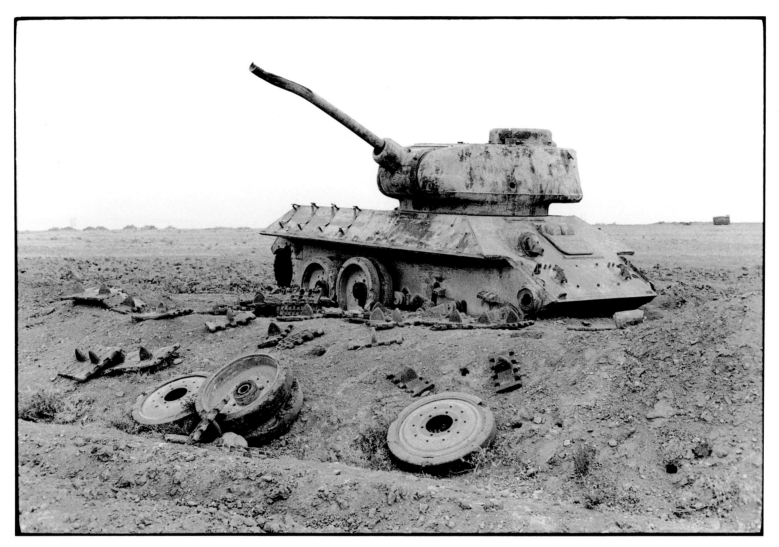

Plate 79

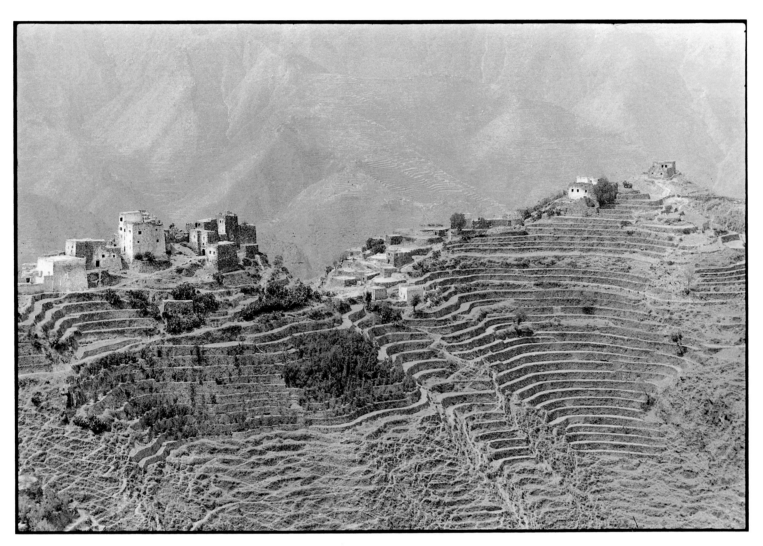

Plate 80

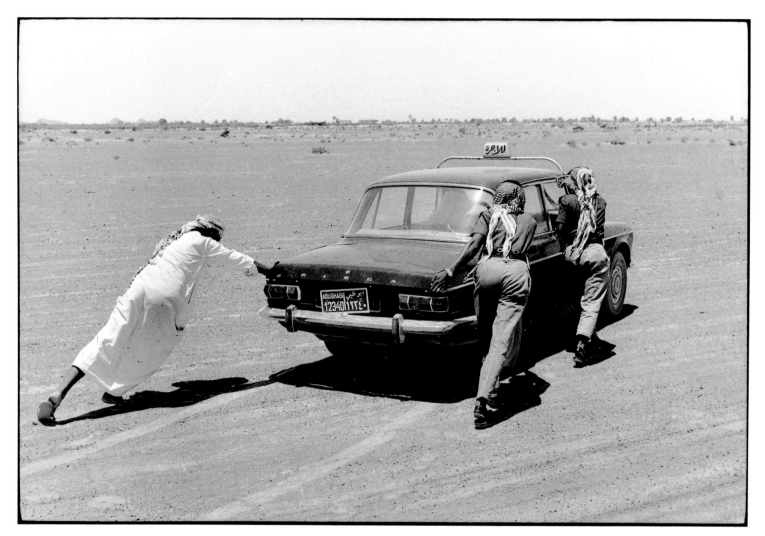

Plate 81

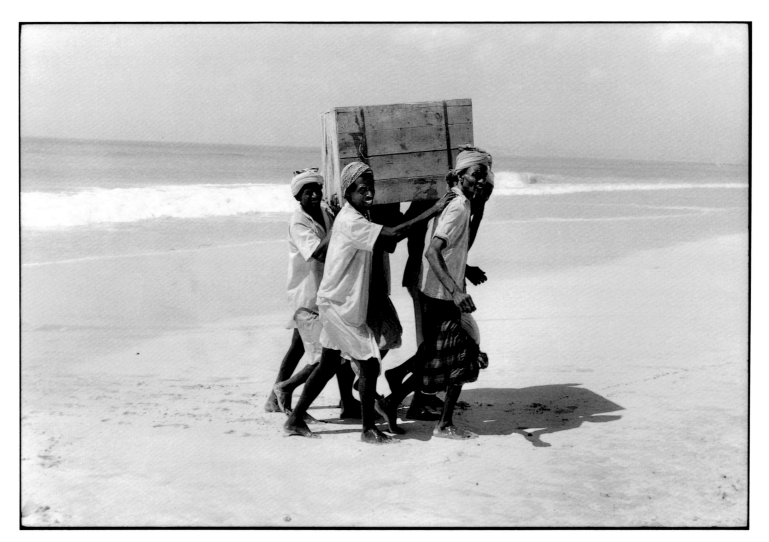

Plate 82

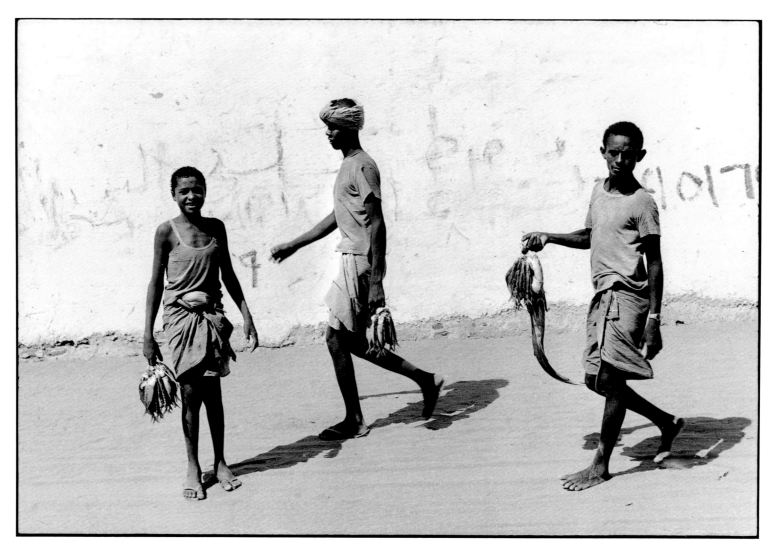

Plate 83

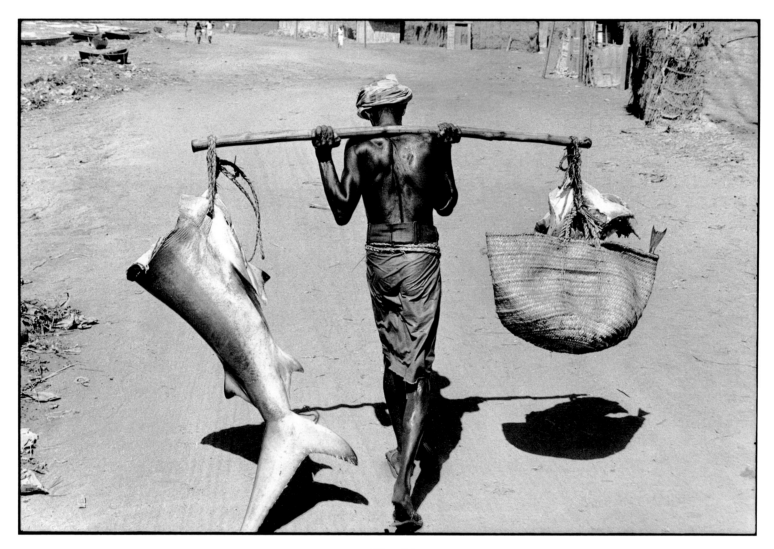

Plate 84

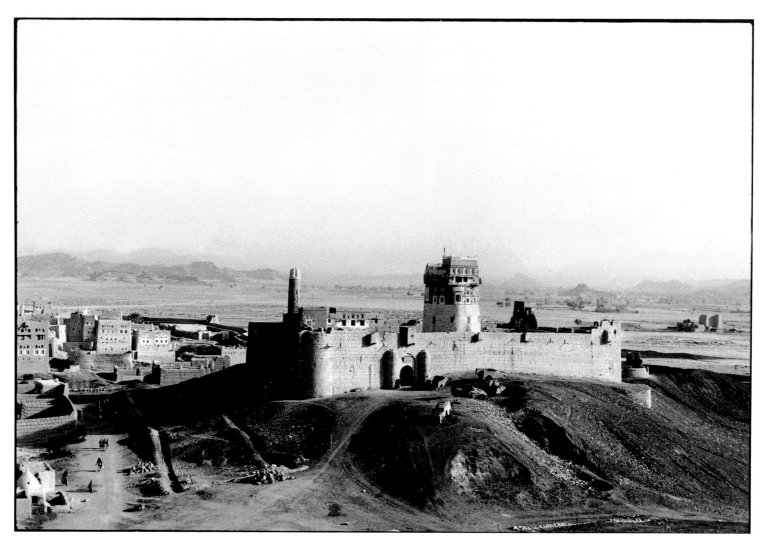

Plate 85

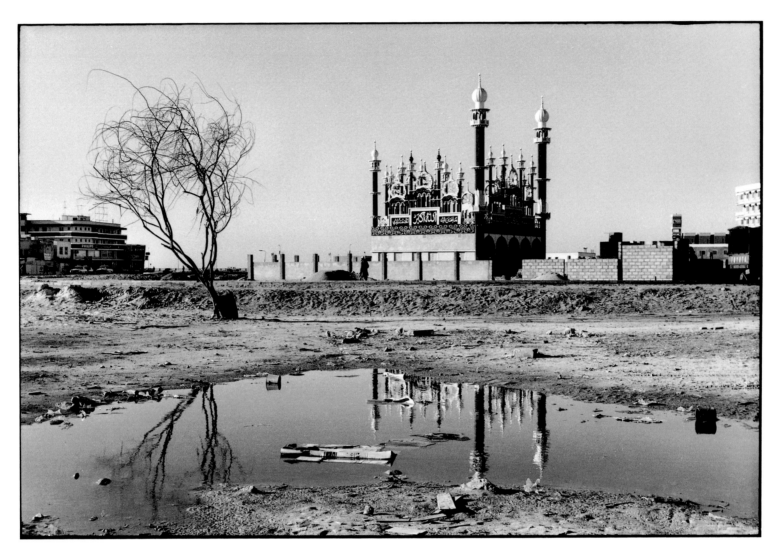

Plate 86

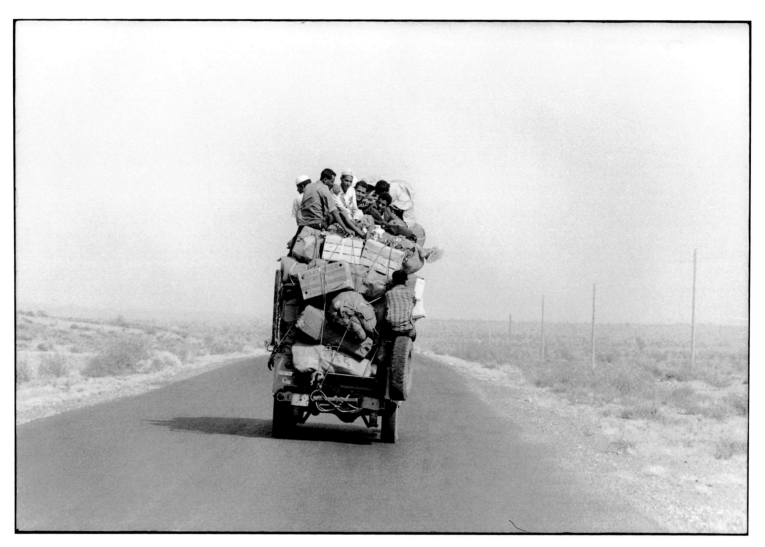

Plate 87

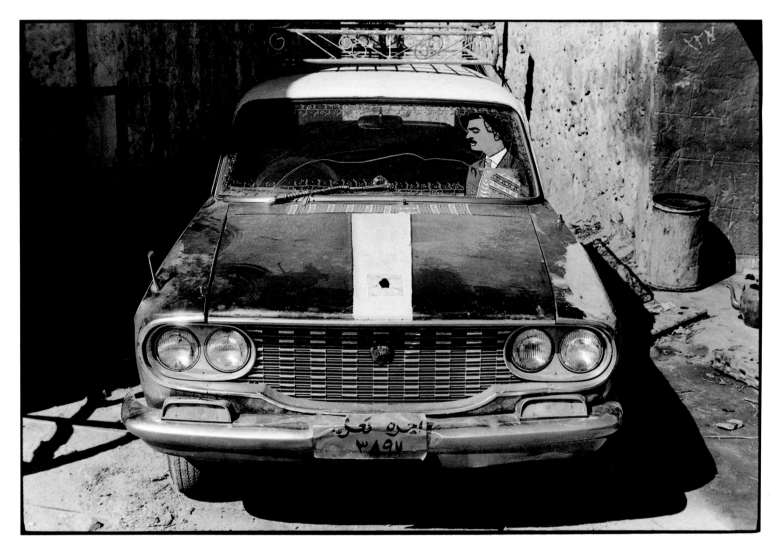

Plate 88

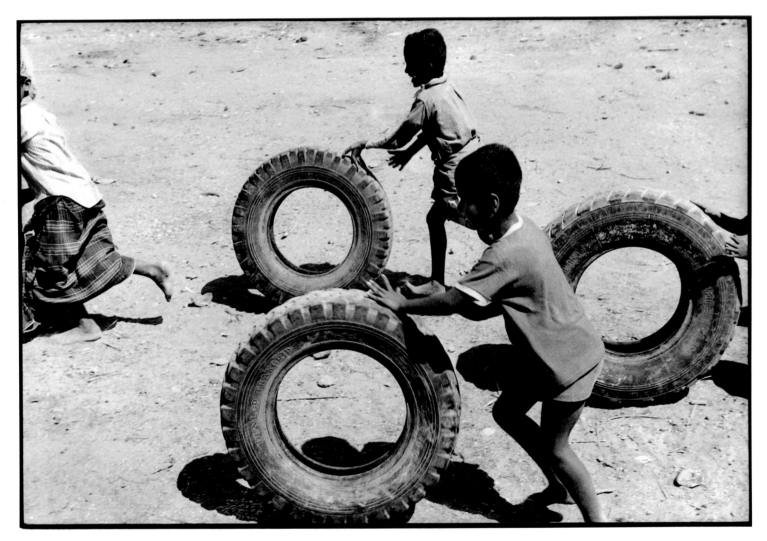

Plate 89

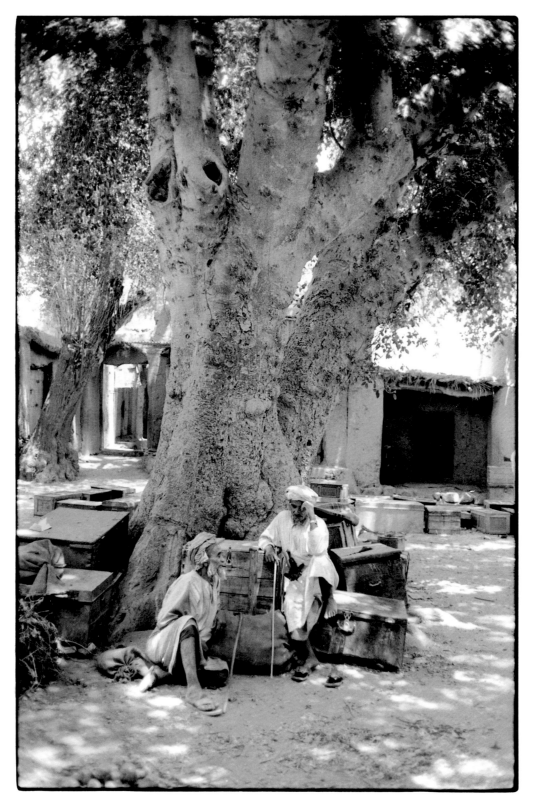

Plate 90

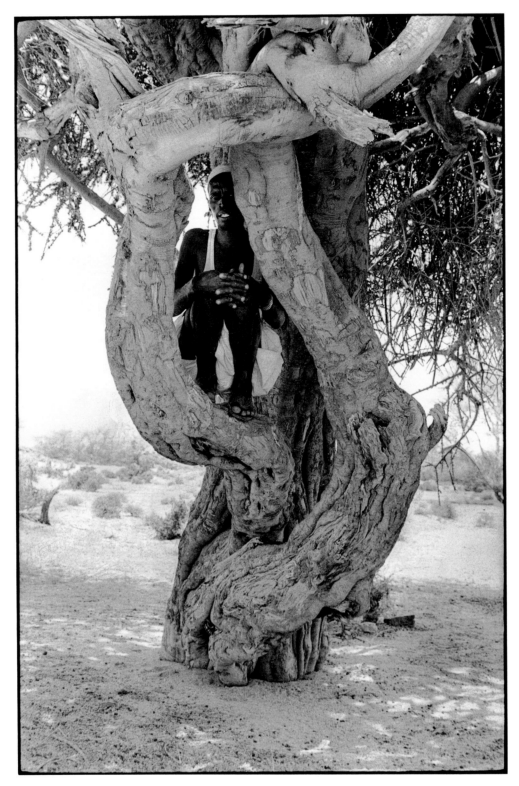

Plate 91

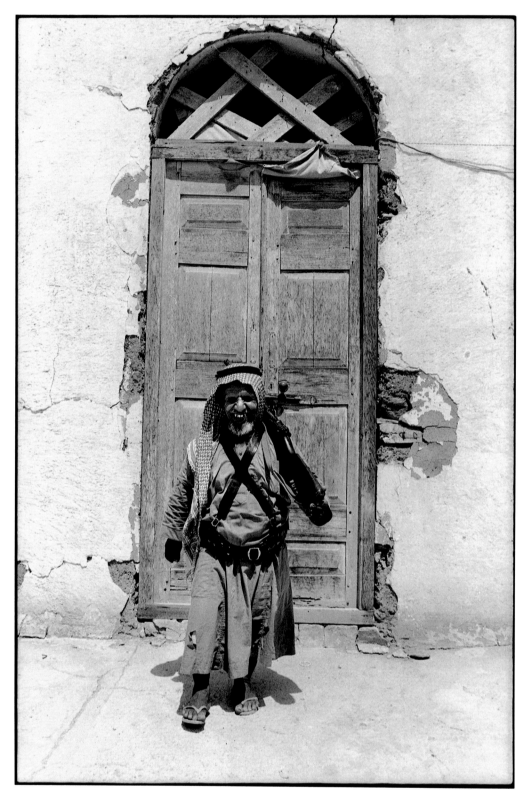

Plate 92

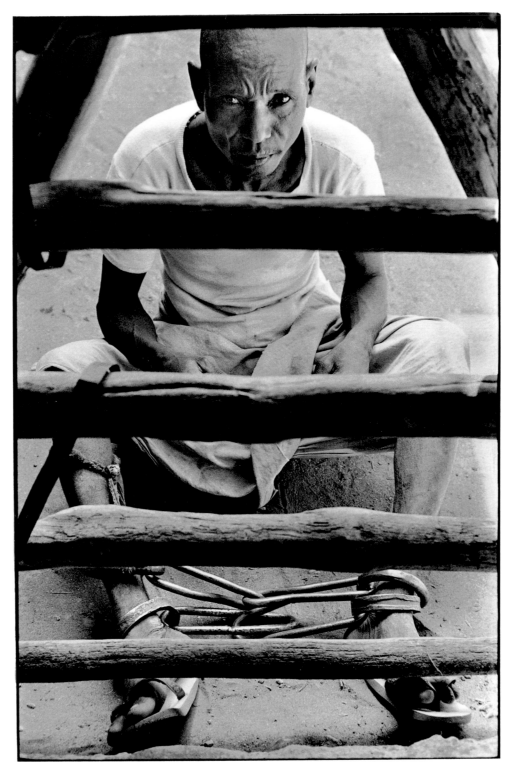

Plate 93

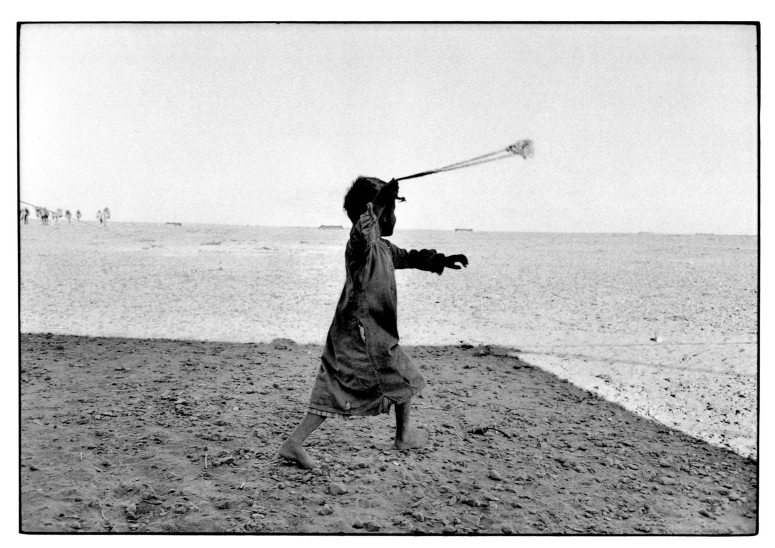

Plate 94

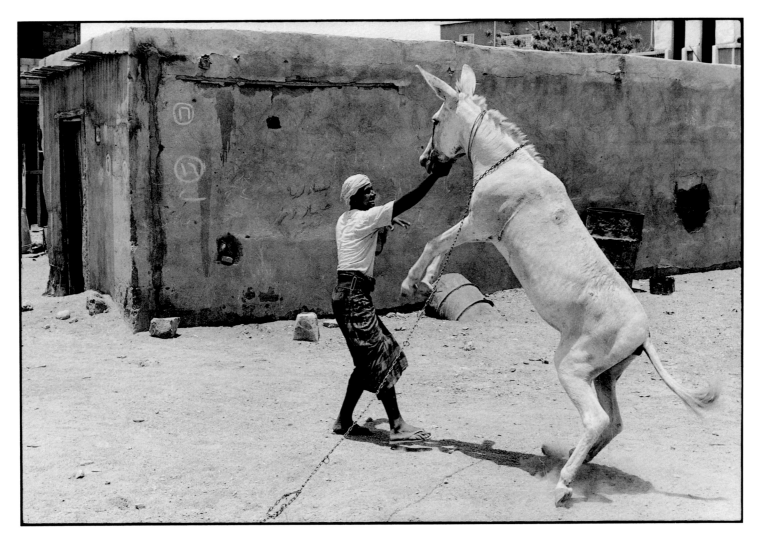

Plate 95

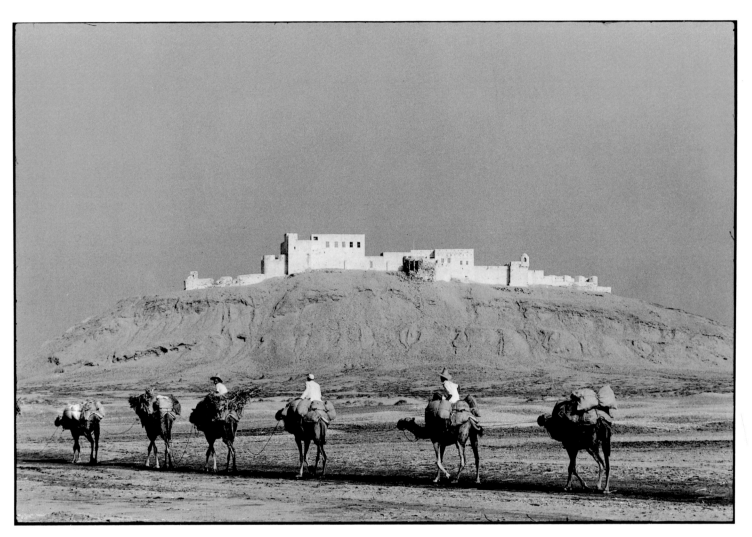

Plate 96

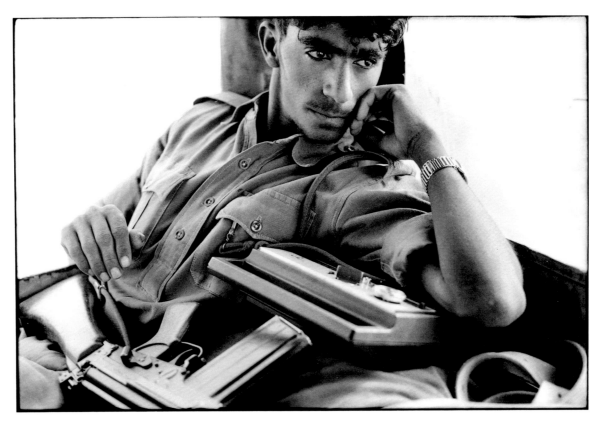

Plate 97

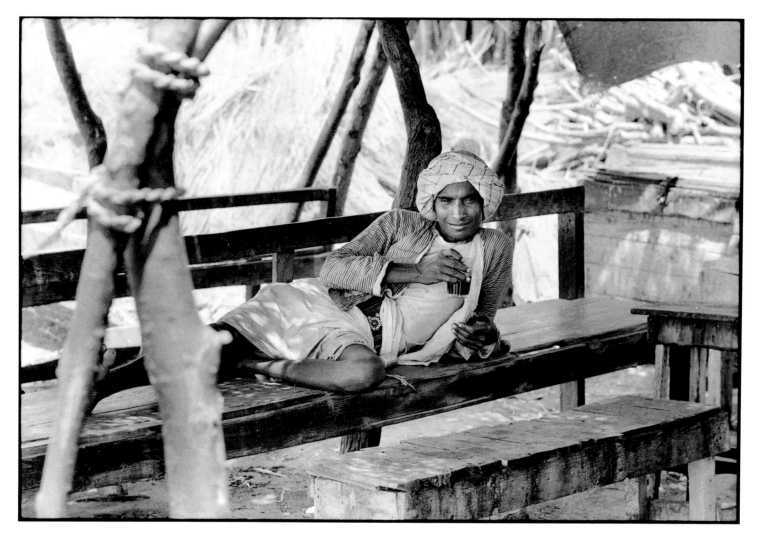

Plate 98

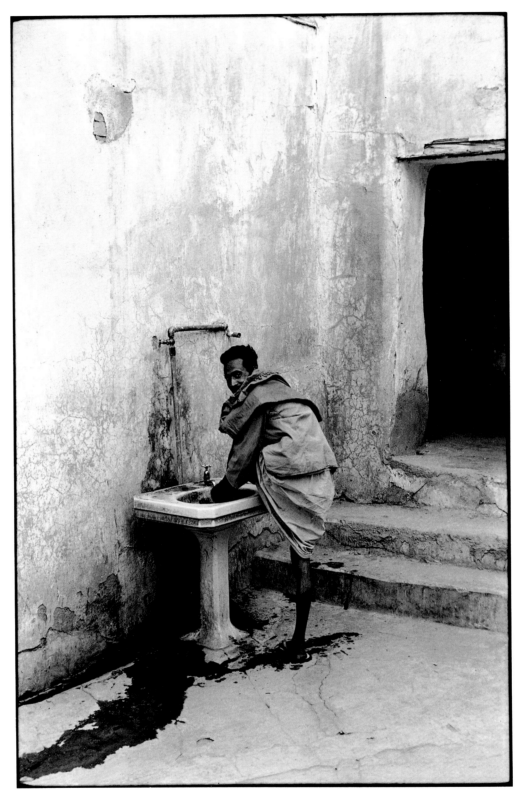

Plate 99

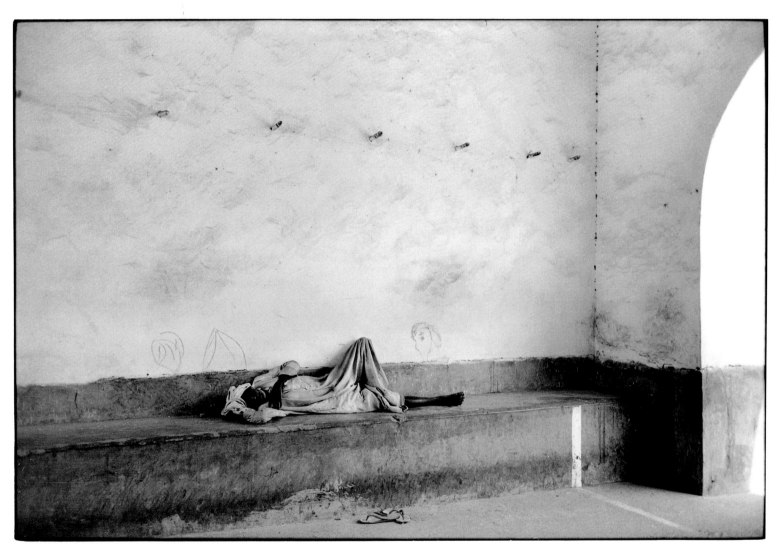

Plate 100

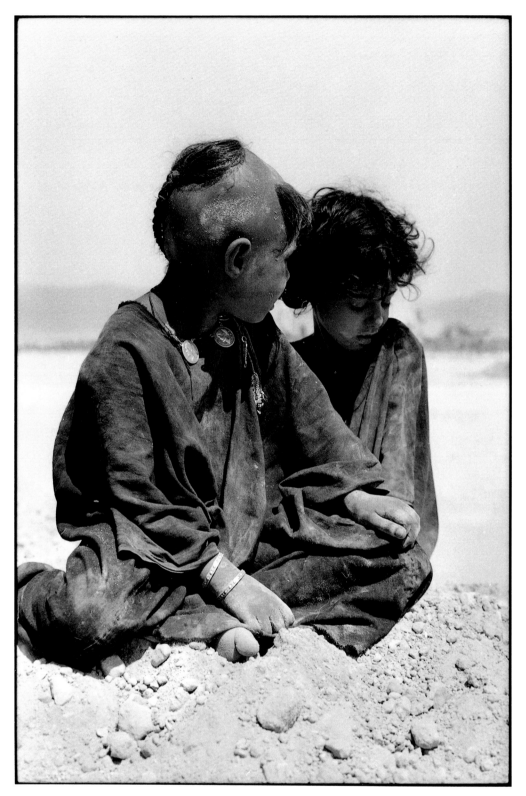

Plate 101

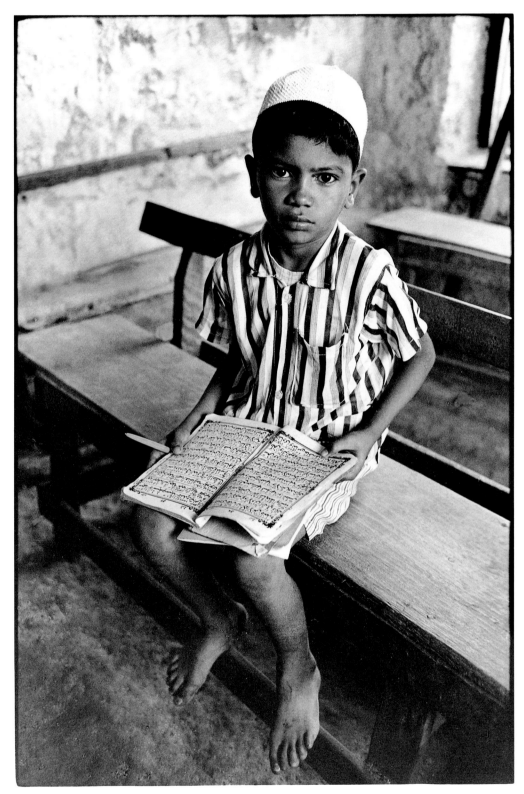

Plate 102

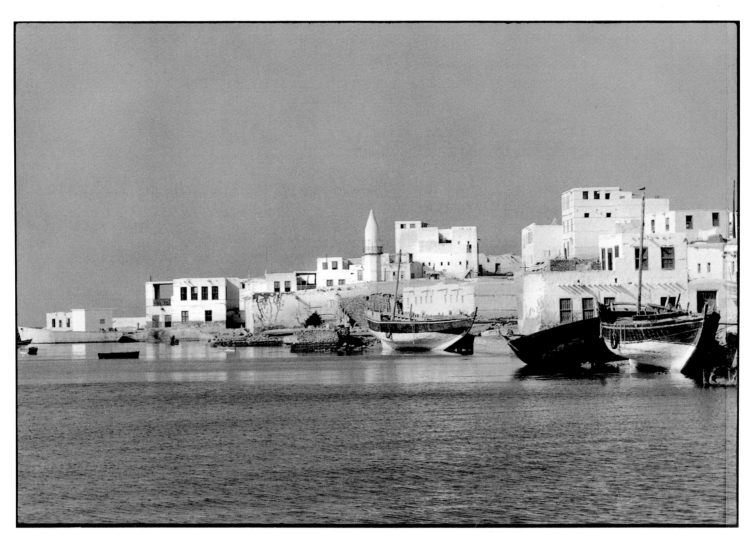

Plate 103

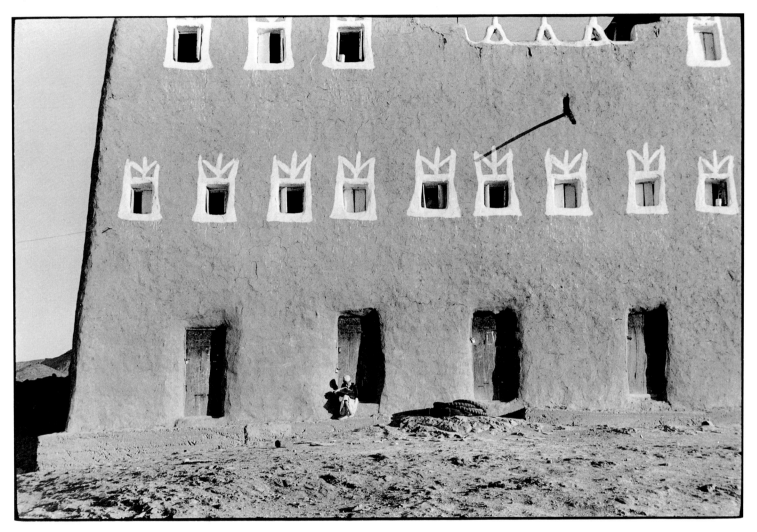

Plate 104

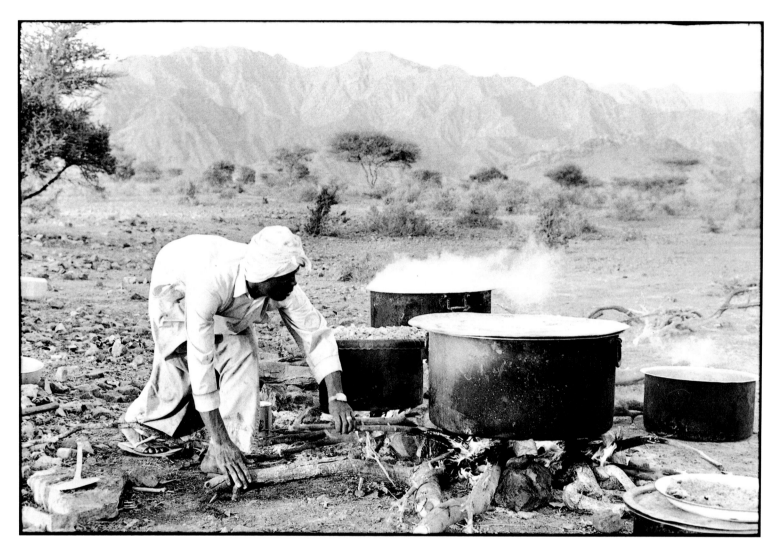

Plate 105

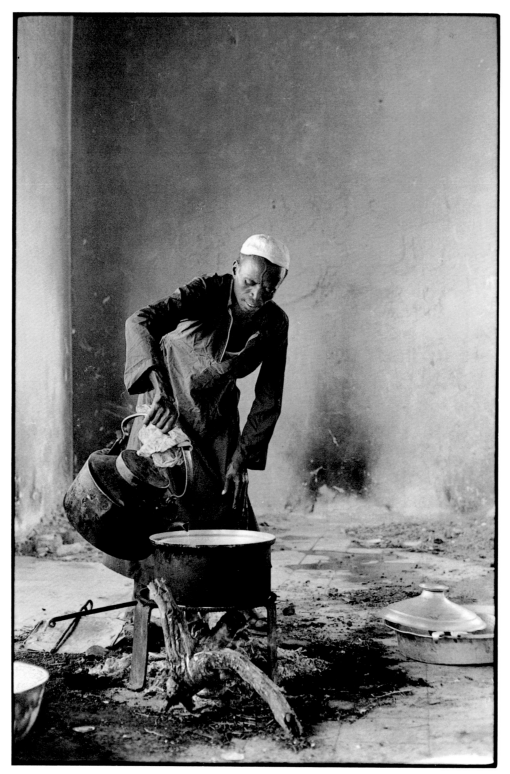

Plate 106

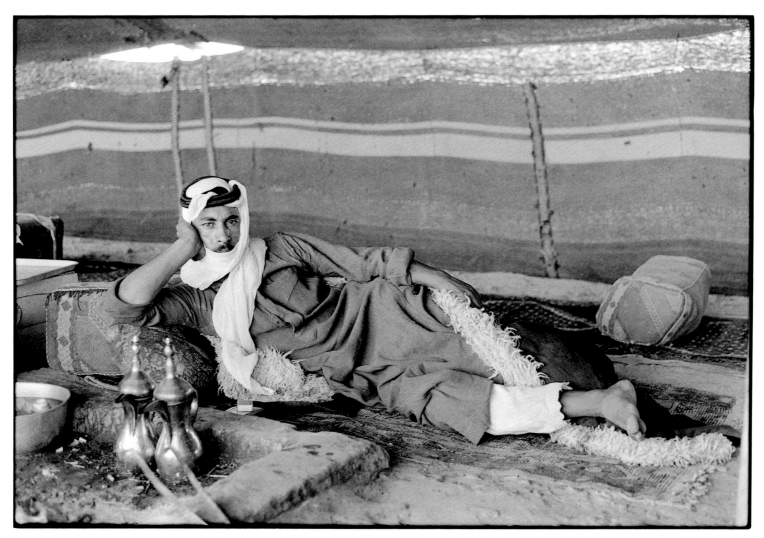

Plate 107

CAPTIONS

1. "The Burden," the port of Mocha, Yemen
2. Boy with wheel, United Arab Emirates
3. Bedouin youth, United Arab Emirates
4. Trainer with horse, near Riyadh, Saudi Arabia
5. "Climbing the Wall," Saudi Arabia
6. Two men at a shop, Rustaq, Oman
7. Four holy men, Hodeida, Yemen
8. Man with large straw hat, Suq'Abs, Yemen
9. Medicine man, Suq'Abs, Yemen
10. Man wearing paper hat, Rustaq, Oman
11. Man with rifle, Hodeida, Yemen
12. Mother and child, Oman
13. My driver, Saudi Arabia
14. Man bathing in a *falaj*, Oman
15. Sailor, Arabian Gulf, Saudi Arabia
16. Sailor, Arabian Gulf, Saudi Arabia
17. Two soldiers with cannon, Hodeida, Yemen
18. Soldier at rest, Hodeida, Yemen
19. The dye works, Hodeida, Yemen
20. Youth sleeping under tree, Jidda, Saudi Arabia
21. Man with white hand, Dubai, United Arab Emirates
22. Shipwright, Arabian Gulf, United Arab Emirates
23. Two fishermen with nets, Arabian Gulf, United Arab Emirates
24. Man carrying water pipe, Jidda, Saudi Arabia
25. Boy sitting on cross, Oman
26. Cigarette vendor, Tai'zz, Yemen
27. Blind man, Jidda, Saudi Arabia
28. Three men dancing with *jambiyas*, Manakha, Yemen
29. Man dancing, Manakha, Yemen

30. Schoolboy, Ibra, Oman
31. Bedouin baby, Buraimi, Oman
32. Blacksmith, Jidda, Saudi Arabia
33. One-armed water carrier, Oman
34. Smokers, Arabian Gulf, Saudi Arabia
35. Youth smoking, Dubai, United Arab Emirates
36. Traditional Tihamah village, Yemen
37. Sheep market, Nizwa, Oman
38. Rope vendors, Hodeida, Yemen
39. Laborers in doorway, Hodeida, Yemen
40. Three men moving rocks, Jidda, Saudi Arabia
41. Man with tool for fluffing cotton, Hodeida, Yemen
42. Man with child, Masandam, United Arab Emirates
43. Tobacco market, Hodeida, Yemen
44. Child in the streets, Ibra, Oman
45. New Aziz Restaurant, Dubai, United Arab Emirates
46. Cinema, Abu Dhabi, United Arab Emirates
47. Bedouin with horse in tent, Jordan
48. Bedouin playing a *rababah*, Jordan
49. Man pushing barrel, Dubai, United Arab Emirates
50. Man carrying sheep and goat, Zabid, Yemen
51. Guard with rifle, kneeling, Nizwa, Oman
52. Guard with rifle, standing, Nizwa, Oman
53. Ibrahim, my cook, Saudi Arabia
54. Five women at the camel races, Abu Dhabi, United Arab Emirates
55. Soldiers exercising, United Arab Emirates
56. Wedding dance in cave, near Torbah, Yemen
57. Man with sword, Abu Dhabi, United Arab Emirates
58. Pulling camel by the nose, Jidda, Saudi Arabia

59. Two soldiers drinking, United Arab Emirates

60. Lifting camel from boat, Jidda, Saudi Arabia

61. Camel in hoist, Jidda, Saudi Arabia

62. Slaughterhouse, Jidda, Saudi Arabia

63. In the hold of a dhow, Dubai, United Arab Emirates

64. Dock worker smoking, Dubai, United Arab Emirates

65. The *wali*'s reception hall, Nizwa, Oman

66. The caves of al Hasa, Saudi Arabia

67. Motorcycle rider, Hodeida, Yemen

68. Donkey rider, Dubai, United Arab Emirates

69. Carpenter, Dubai, United Arab Emirates

70. Loading bags into dhow, Dubai, United Arab Emirates

71. Water carriers with donkeys, Jidda, Saudi Arabia

72. Water carrier, Jidda, Saudi Arabia

73. Tea house in Zabid, Yemen

74. Carrying buckets of water, Jidda, Saudi Arabia

75. Guard resting in doorway, Oman

76. Oarsmen, Salalla, Oman

77. Men launching boat, Salalla, Oman

78. Camel and fish, Arabian Gulf, United Arab Emirates

79. Egyptian tank, near Sana'a, Yemen

80. Terraced fields, Hajjah, Yemen

81. Pushing a taxi, al-Jauf, Oman

82. On the beach of Salalla, Oman

83. Three youths with fishes, Hodeida, Yemen

84. Man with shark, Hodeida, Yemen

85. Fort of Saa'da, Yemen

86. "Mickey Mouse" Mosque, Abu Dhabi, United Arab Emirates

87. Overloaded Toyota, Bayt al-Faqih, Yemen

88. "Nasser" in car, Tai'zz, Yemen

89. Boys pushing tires, Oman

90. Resting in the market square, Bahla, Oman

91. Ibrahim in tree, Saudi Arabia

92. Dwarf soldier, Asir, Saudi Arabia

93. Prisoner, Yemen

94. "David," Jordan

95. Man wrestling with mule, Jidda, Saudi Arabia

96. Camel caravan with fort, al-Luhayyah, Yemen

97. Soldier resting, El Ain, United Arab Emirates

98. Café, Jizan, Saudi Arabia

99. Man washing feet in sink, Yemen

100. Man resting in doorway, Muscat, Oman

101. Two children, Salalla, Oman

102. Schoolboy, al-Luhayyah, Yemen

103. Port of Al Wadj, Saudi Arabia

104. Mud-walled house, Saudi Arabia

105. Preparing wedding feast, United Arab Emirates

106. Ibrahim cooking, Saudi Arabia

107. Coffee server, reclining, Jordan

ACKNOWLEDGMENTS

I want to thank numerous people for making this photographic project possible. I was blessed to have had so much support. In Saudi Arabia, I was hosted by Prince Muhammad Ibn Faisal; in the Yemen by Michael and Malek Sheehan, Tom Seibert, and Bob Walsh; in Oman by Jack and Ottley Sims; Colonel Malcolm Dennison, chief of Army Intelligence; and the Jebel Regiment; in the United Arab Emirates by Paul and Suzanne Bergne, and Gail Hughes; in Jordan by Dany Chamoun; and in Beirut by James and Janet Horgen and Feris Glubb.

I want to thank Issam Azzam, who organized my first trip into the desert; Hugh D. Auchincloss and John Atwater Bradley, whose patience and help were crucial in my bringing this book to completion; Munirah Alatas Khalifa and Sara and Salman Binladen for their magnificent generosity; Gilbert and Ildiko Butler, Michael Sheehan, Virginia Treherne-Thomas, Cristina Noble, and Penny Vestner for their loyalty; Sir John and Lady Glubb for their encouragement; and Susan Poole, my good friend and writer, who helped me capture my Arabian days in words.

Also to thank are: Chris Hart, Clive Russ, Marsha Goldstein, Jennifer Gillooly, John Hames, Ken Heyman, Lucy Hodgson, Dr. Zaineb Istrabadi, Gregory Kammerer, Rob Lawson, Dorothy Martin, Mary Ellen Mark, Marika Moosbrugger, Marta Norman, Renée O'Gara, Pam Sherman, Angela Weidinger, Jody Wells, Jed Wilcox, Mustafa Zaidi, Meridian Printing of East Greenwich, Rhode Island, and the editors of Syracuse University Press.

I have not forgotten the people of Arabia, whose hospitality helped define my experience of the Middle East.